IMAGES
of America

MEDFORD

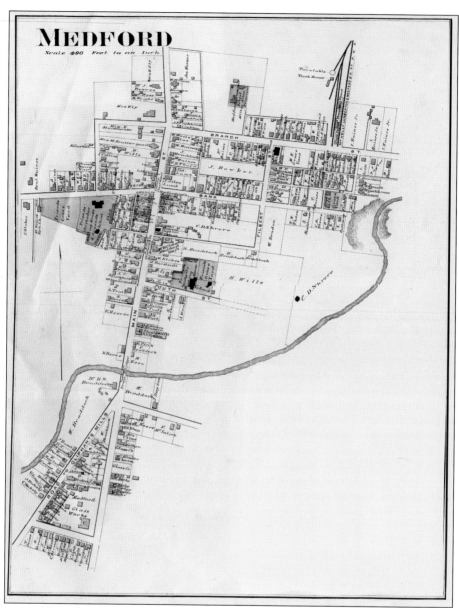

This map of the village of Medford was taken from the Combination Atlas of Burlington County, New Jersey, by J.D. Scott of Philadelphia in 1876. It roughly shows the borders of the village as the Rancocas Creek to the east, Trimble Street to the south, Allen Street to the west, and the Broad Street area to the north. (Courtesy of the author.)

ON THE COVER: Kirby's Mill, the only remaining mill in Medford, is located on Church Road on the southern branch of the Rancocas Creek. The sawmill and gristmill, which began operating in the late 1700s, was the last commercial water-powered mill in New Jersey. In 1969, the Medford Historical Society purchased the still-operating mill from the Kirby family. Kirby's Mill was entered on the New Jersey and National Registers of Historic Places in 1971. Taken in 1910 by Medford photographer William B. Cooper, the photograph shows the main building housing the gristmill. Members of his family are in the canoe. (Courtesy of Beverly Mickle.)

IMAGES
of America

MEDFORD

Dennis McDonald

ARCADIA
PUBLISHING

Published by Arcadia Publishing
Charleston, South Carolina

Printed in the United States of America

Library of Congress Control Number: 2011935795

For all general information, please contact Arcadia Publishing:
Telephone 843-853-2070
Fax 843-853-0044
E-mail sales@arcadiapublishing.com
For customer service and orders:
Toll-Free 1-888-313-2665

Visit us on the Internet at www.arcadiapublishing.com

This book is dedicated to my mom and dad, who believed in me, and to my extended family, who always supported me.

CONTENTS

ACKNOWLEDGMENTS

Undertaking a photographic book on Medford history is a journey. The first step began with the Medford Historical Society and the volunteers, George Ney, Pete Canale, and Don Davis. They opened the back rooms of Kirby's Mill and allowed me access to the vast collection. Next, I stopped at the door of Lois Ann Kirby and introduced myself. After our first meeting, she welcomed me back into her home week after week where I soaked up the history of Medford. I am truly grateful to her and her husband, Engle, for all of their guidance.

A special warm word of thanks to Beverly Mickle, who, with her late husband, Everett, spent years collecting and preserving images of Medford. She trusted me with glass negatives and rare prints for use in this book.

Also, thanks to postcard collector Bob Duerholz, businessman Ed Gager, family farmer Roberta Shontz, YMCA camps chief executive officer Keith VanDerzee, baseball enthusiast Larry DeVaro, Medford police captain Keith McInich, family farmer Eric Johnson, railroad historian Frank Kozempel, and Milton Allen School teacher Maureen Schoenberger. Thanks to June Brown Haines, Carl Pellegrino, Brenda Parks Morris, Jim Angermeier, Dale Carns, Martin Ellis, Tom Rende, Gene Sharpless, Bonnie Harriett-Crosby, Pat Moore, Martin Ellis, Ken Middleton, Fred Atkinson, Charles and Grace Haines, the Henisee family, Diane Stiles Cosaboon, Doris and Harry Harrison, Shirley Bunning, Erna Scheibner, Grace Ballinger Haines, Mae Novelle, Jean Wells, Fred Atkinson, Mary Bauer, Pat Moore, and Frank Valocik.

Organizations who also contributed were the *Burlington County Times*, the Burlington County Historical Society, the Medford Police Department, the Medford Lakes Colony, the Girl Scouts of Central and Southern New Jersey, the Milton Allen School, and the Medford Society of Friends.

The photographer behind many of the images in the book is William Cooper. He lived and worked in the late 1800s and early 1900s documenting Medford using large glass plates. As a fellow photographer, I'd like to compliment Mr. Cooper on his vision.

The final steps of my journey were taken with my editor, Abby Henry, at Arcadia Publishing.

Thanks and love to my wife, Rose Shields, for her computer skills and patience.

INTRODUCTION

The Rancocas Creek has been central to Medford's history for hundreds of years. The Lenape Indians used the waterway for transportation and drinking water and the area around the creek for hunting and camping. Lifelong Medford residents Roy Mickle and Raymond Powell found thousands of Indian artifacts on farms and woods testifying to the Native American presence. Two roads in the town began as Indian trails not much wider than a man's shoulder. Stokes Road was known as the Shamong Trail in Colonial times. Likewise, Tuckerton Road was known as Manahawkin Trail.

The early settlers of Medford, members of the Religious Society of Friends, traveled up the Rancocas Creek by canoe from Mount Holly and Burlington in the early 17th century. The first known settler, John Haines, lived in a cave along the banks of the Rancocas as he began to clear the land for farming. The part of the Rancocas in Medford became known as Haines Creek as a result. Other Quakers followed Haines upstream, cleared the land of trees, and started lumber mills. By 1800, seven sawmills were operating and shipping lumber down the Rancocas to Lumberton. The timber was also used in the making of charcoal. Used locally by bog iron furnaces, it was also shipped downstream and used in places like the Philadelphia Mint.

With the abundance of water power, timber, and iron ore, furnaces were built in the township. Charles Read, one of the large landowners in the area, built ironworks in Taunton and Etna (now Medford Lakes) and extended his empire to Atsion and Batsto. Taunton Forge supplied shot and balls to soldiers serving in the Revolutionary War.

The cleared land allowed farming to begin. Hay was an important crop for early farmers. Their cattle needed to be fed during the winter, and the crop was in high demand in the cities. The importance of hay is shown by settler John Haines, who left his Medford hay landing and nearby lands to his grandson in his will. As recently as 1911, Frank Gager was a hay dealer in Medford.

Cranberries came to dominate the local landscape when the sawmills no longer had the raw material to keep them running. The water from the Rancocas Creek that once powered the mills was now used to water the berry fields, but it is no longer used for transportation. Railroad lines were built to serve the town. People and products began to arrive and depart by rail. By the late 1800s, two lines served the town—the Mount Holly, Lumberton & Medford Railroad and the Philadelphia, Marlton & Medford Railroad. The railroads were integral to Medford becoming the center of the cranberry industry. Cranberries from Medford were shipped all over the United States and Canada. Cranberries were carried on transatlantic ships to prevent scurvy when citrus fruits weren't available. Packinghouses were built throughout the township to capitalize on the industry. The Jennings Packing House, which now houses the Medford Senior Center, was one of them. In the late 1800s, the cranberry harvest employed 350 to 500 people in the Centennial Lake area alone.

In the early 1800s, land developer Mark Reeve arrived in Medford. He began to buy land along Main Street and opened his first shop at the corner of Main Street and Friends Avenue. Reeve had great plans for the town, laying out the major streets in the village with 18-foot alleys at the rear of the Main Street properties. Some of those alleyways later became Maple and Charles Streets. His layout of Medford has changed little over the years. He is also credited with the naming of the town. He traveled to Medford, Massachusetts, and was so impressed with the New England town that he returned anxious to have the Upper Evesham Township area named Medford.

As Medford grew, it demanded its own identity. In 1847, the town separated from Upper Evesham Township, keeping its town hall located at Cross Roads, where Church Road crosses Mount Holly Road. The center of the township eventually moved from Cross Roads to the village of Medford. Wagons were already passing through the village and heading down the Marlton Pike, carrying dairy products, vegetables, and fruit to Camden and Philadelphia. The village was the center for tradesmen, including blacksmiths, carpenters, shoemakers, coopers, butchers, and various shopkeepers. The intersection of Main and Union Streets was a bustling area when the Indian Chief Hotel was built in 1810 by cabinetmaker Richard Reeve to serve stagecoaches passing through.

Industries also started to open in town. Glass making was one of the first because of the availability of sand in the area. It is thought that the first glass company producing window panes opened in 1825. Where the first glass factory was located is unknown, but subsequent factories were located within the triangle of South Main, Mill, and Trimble Streets. Star Glass Works, operating from 1894 to 1923, was the most well known. The factory at its peak employed 250 people working in shifts around the clock. The company produced hand-blown glass bottles for numerous companies, including the first lock-top catsup bottle for Campbell's Soup.

When the Quakers arrived in Medford, one of the first things they did was open a school around 1759 on their Union Street property. The school served a dual purpose until the first wooden meetinghouse was built in 1762. The present brick meetinghouse opened in 1814. A second Quaker meetinghouse, the Hicksite Meeting House, was erected on South Main Street after a split within the congregation in 1842. In 1955, the two meetings were reunited.

As Medford grew, other churches opened. The Methodist congregation formed in 1816 and built its first church in 1827. Its second building was constructed in 1854 on Branch Street, and the congregation remained there for more than 100 years. In 1842, the Baptist congregation opened its doors in its first church on Bank Street. Fifty years later, the building that stands at the corner of Bank and Filbert Streets was built. The Episcopal church began in 1868 when it held meetings in members' homes. In 1875, the cornerstone for St. Peter's Church was laid at the corner of Union and Allen Streets.

At least four rural schools operated in Medford in the early 1800s. Although known by other names over the years, the Chairville School, the Kirby's Mill School, the Brace Road School, and the Cross Keys School served the children of farmers and outlying communities. Teacher and principal Milton Hannah Allen shaped education in the township when the schools were consolidated into the Filbert Street School in the village in the late 1800s into the early 1900s. His legacy lives on with his namesake school on Allen Street. Probably one of Medford's most famous students was James Still. He only attended the Brace Road School for a few months, but he attained fame as the "Black Doctor of the Pines."

With Medford's continued expansion in the 21st century, the Rancocas Creek serves as a recreational waterway. Travelers can now canoe or kayak from Main Street to Kirby's Mill. The trip down the creek today feels like a quiet journey into the town's past.

One

THE VILLAGE

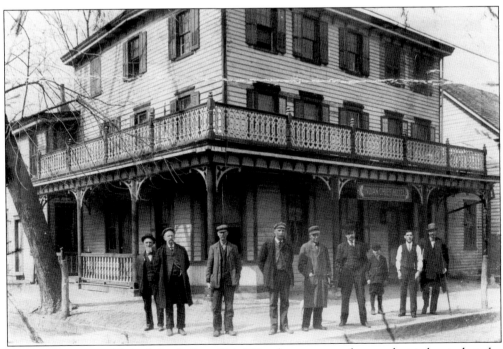

Richard Reeve established the Indian Chief Hotel, a stagecoach stop that is located at the intersection of Main and Union Streets. Samuel Hartman, who operated the hotel when it opened in 1810, chose the name because the lodge of an Indian chief supposedly stood on the site. The building underwent many changes before a fire destroyed it in 2008. It was rebuilt in 2010. (Courtesy of Beverly Mickle.)

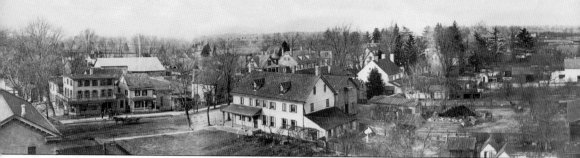

William B. Cooper made this panoramic photograph from a windmill tower located beside Reeve Mingin's house near Bank and Main Streets. The combined photographs show the village north of Bank Street in 1906. At left are the Indian Chief Hotel and the Lamb House with a horse-drawn wagon headed down Main Street. A mixture of houses, barns, and businesses are seen as

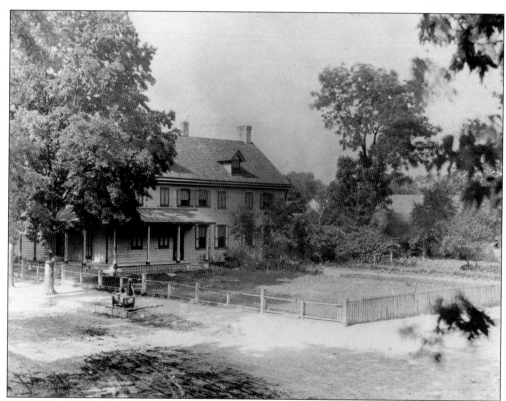

The John Allen Lamb house was located on the northeast corner of Main and Bank Streets. It was the first purchase of land by developer Mark Reeve and was used as a house and store. John Allen Lamb was the second owner of the property. In the 1940s, Tommy Azman bought the Lamb House and called a bar that he opened inside it the Indian Chief Tavern. Around 1960, his stepson, Harry Sosangelis, built a new restaurant on Route 70, and the Indian Chief's name was transferred to it. It was used as a residence and business until it was torn down in October 1964. (Courtesy of Beverly Mickle.)

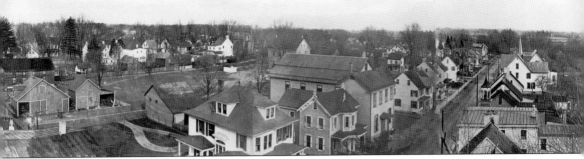

the camera moves across the backyards, including a cranberry packinghouse, which is now the township's senior center. The 180-degree view comes around to East Bank Street, where Grange Hall and part of the Filbert Street School are shown. The tower of the fire company and the steeple of the Baptist church are visible at right. (Courtesy of Beverly Mickle.)

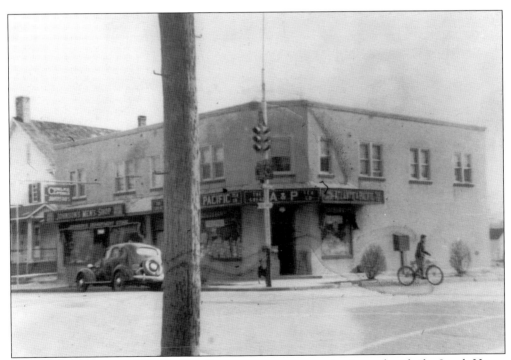

The Great Atlantic and Pacific Tea Company grocery store is pictured with the Lamb House at left in 1927. Between them is Johnson's Men's Shop. Located at the intersection of Bank and Main Streets, the stores were built in the empty lot between the Lamb House and Bank Street. It was the first chain store to open in the village, providing competition to the "mom and pop" stores. (Courtesy of Beverly Mickle.)

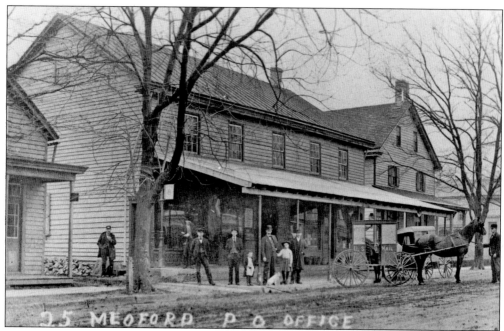

In March 1820, Medford had established its own post office with Oliphant Shinn as the first postmaster; the office was located in his parlor. By 1906, the Medford Post Office moved to North Main Street next to the Lamb building. Pictured here are, from left to right, rural carrier William Cramer, Jim Swain, Joe Stackhouse, Elmer Dyer (postmaster), unidentified, Harry Knight, Verna Knight, Ed Warner, and Kay Haines in front of the horse and mail wagon. (Courtesy of Diane Stiles Cosaboon.)

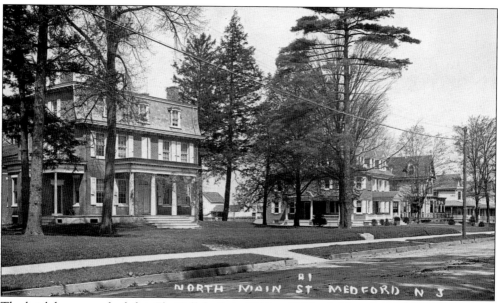

The brick house on the left is Ely Hall, built in 1844 at 40 North Main Street by Dr. Henry Ely. He practiced medicine with Dr. Josiah Reeve, who lived nearby. The 1982 Heritage Studies Survey states that this house is a landmark presence in Medford Village. The house to the right is the Joshua Wills House, which was built in 1910. (Courtesy of Bob Duerholz.)

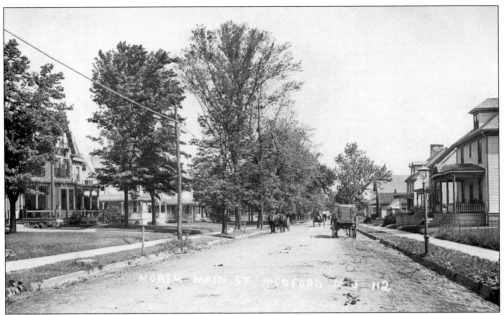

Looking out of town on North Main Street in the early 20th century, the Westcott House is on the right; it doesn't appear much different today. The view shows lawns, sidewalks, curbs, street lights, and telephone poles lining the dirt streets that are filled with horses and carriages. (Courtesy of Bob Duerholz.)

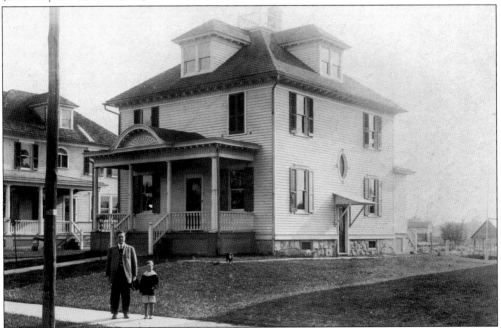

Lewis Westcott and his son Donald stand together in front of his home at 75 North Main Street in 1910. He was the stationmaster of the Philadelphia, Marlton & Medford Railroad, whose terminus was located just a few buildings away. Built in 1907, the porch was enclosed in the early 1920s. There have been only two owners of the house in the 100-plus years of its existence. Engle and Lois Ann Kirby currently occupy it. (Courtesy of Engle and Lois Ann Kirby.)

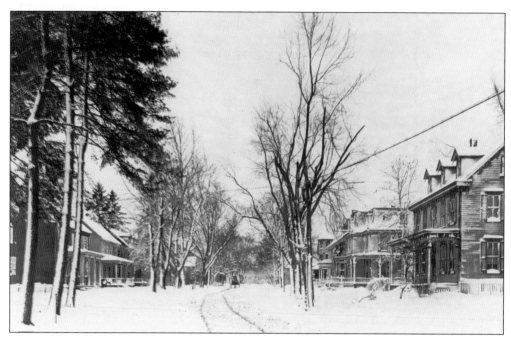

These views show North Main Street looking towards Union Street in 1906. In the bottom photograph, Verna Knight stands on the sidewalk on skates in front of the house on the corner of Cedar and Main Streets. The other people are unidentified. The top photograph looks in the same direction on a snowy day. In the winter photograph, the home on the left is that of Dr. George Haines, the first registered physician in Medford. There is evidence that his home was a stop on the Underground Railroad, according to a historic survey in 1970. (Both, courtesy of Beverly Mickle.)

The Wills House, built by Joshua Wills in 1910, is located on North Main Street. Mr. Wills had the house that was at that location moved to 26 Cherry Street so that he could build this brick home. The home to the right, located at 50 North Main Street, is known as the Joshua Reeve house. The first dentist in Medford, W. Roland Dunn, had an office in the southeast corner of the house in the 1930s. At the far right is the Weeks/Bowker house, showing the open porch before it was enclosed for the Genie Lamp Store. (Courtesy of Gene Sharpless.)

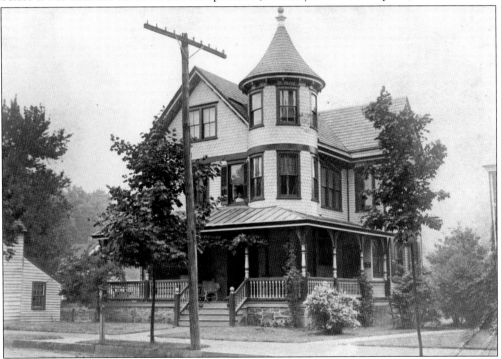

The Israel Garwood home is located on North Main Street next to the township gazebo. In the mid-1900s, Evelyn Belcher owned the home, and the Nail House was located at the rear of the property. She donated the rundown building to Dr. Edward Jennings, who moved and relocated the building to his farm. Today, the Nail House remains there in an expanded form. (Courtesy of the Medford Historical Society.)

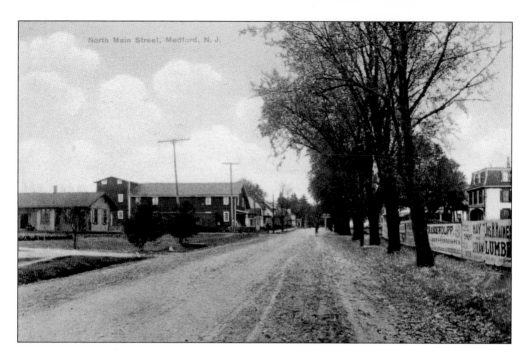

The top postcard from the early 1900s shows the Philadelphia, Marlton & Medford railroad station at left with Kirby Bros. Feed Store behind it. Crossing North Main Street are the train tracks with a "Look out for the Locomotive" sign at right on the road. At right are advertising signs that were placed along the exterior of the fence of the Medford Field Club baseball field. In the bottom photograph is a closer view of the train tracks located near the Kirby Bros. store. (Both, courtesy of Bob Duerholz.)

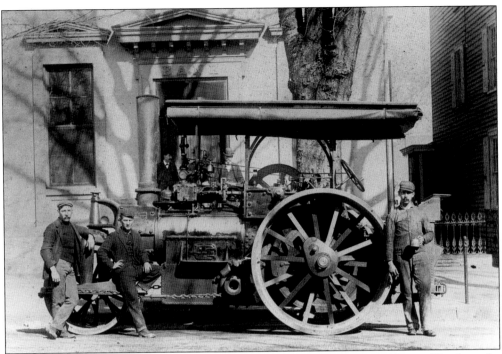

In 1898, a steamroller with its crew rests in front of the Burlington County National Bank on the corner of Bank and Main Streets. It was used to flatten the road to remove ruts and to change the grade on South Main Street to make the hill less pronounced. (Courtesy of Beverly Mickle.)

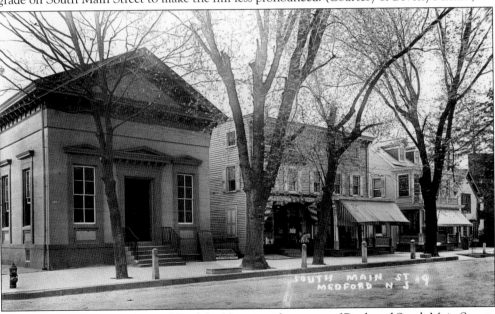

The Burlington County National Bank building is at the corner of Bank and South Main Streets in this view. The bank went through many owners and last housed the Farmers and Mechanics Bank. It currently sits empty. The building next door is Henry P. Thorn's Drug Store around 1910. The store remained a pharmacy after changing hands throughout the years and became a Rexall Drug Store in the 1970s. (Courtesy of Beverly Mickle.)

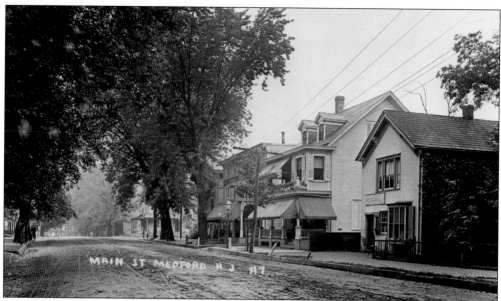

This view of the east side of South Main Street was taken looking north. The Schopfer Bakery is at right with a sign advertising breads, pies, and cakes. Next is the home of Isaac Stokes, built in 1813, the Henry P. Thorn's Drug Store, and the Burlington County National Bank. (Courtesy of Beverly Mickle.)

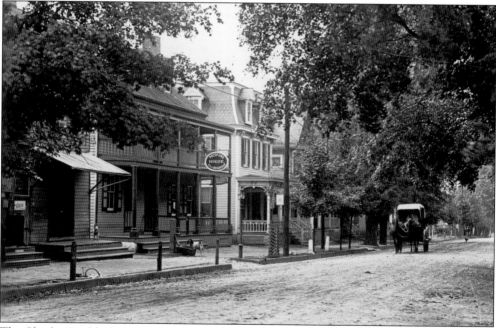

The Charles Braddock Medford House on South Main Street is shown with the butcher shop at left in 1904. Established in 1823 as Burr's Tavern, it was destroyed by fire in the winter of 1843, leaving only the stone foundation. This three-story frame-and-clapboard structure was rebuilt in 1844, closely following the original plans of the 1823 structure. Charles Braddock purchased the building in 1898. Today, it houses a popular restaurant known as Braddock's Tavern. (Courtesy of Beverly Mickle.)

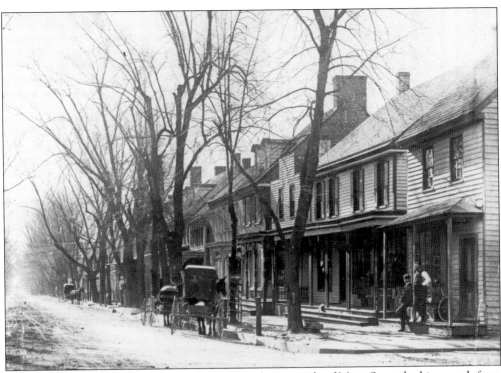

The top photograph shows stores and houses on the west side of Main Street looking south from the corner of Union Street around 1890, before changes were to take place. The building on the right was relocated to Maple Street and the next building was relocated to Union Street and houses the New Jersey School of Music. In their place, Harry T. Allen's General Merchandise store (below) was built. Allen's store also had a branch in Vincentown, New Jersey. (Above, courtesy of Beverly Mickle; below, courtesy of the Medford Historical Society.)

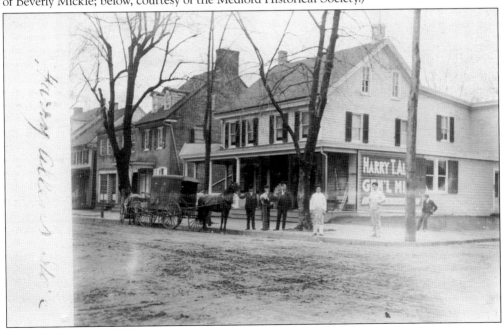

The Iron Bridge, built around 1875, was located at the foot of South Main Street where it crossed the Rancocas Creek. Looking north, an unidentified boy stands in the middle of the bridge around 1905. The bridge connected the main part of the village with the glass factory, the factory workers' houses, and their company store. (Above, courtesy of Beverly Mickle; below, courtesy of the Medford Historical Society from the Clyde LeVan Collection.)

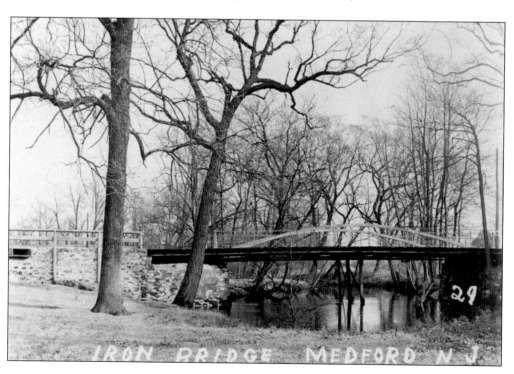

In 1909, a concrete bridge was built replacing the iron bridge over the Rancocas Creek, making it twice as wide as the former bridge. After being flooded over in 1940 and 2004, and after more than 100 years of constant use, it still remains today. (Above, courtesy of the Medford Historical Society; below, courtesy of Bob Duerholz.)

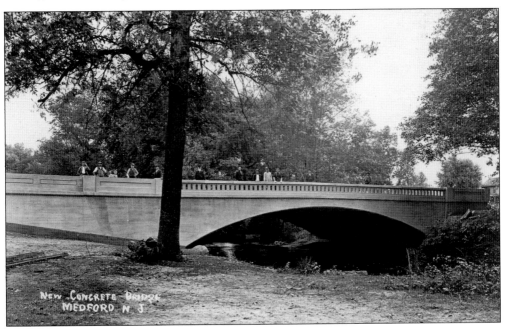

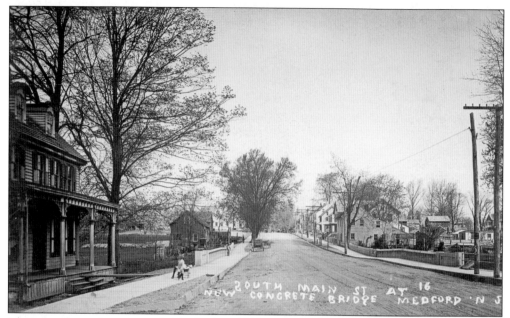

This view shows the concrete bridge built in 1909 on South Main Street looking up the hill into the village. The widening of the bridge caused Dr. Richard Braddock's house (left) to be too close to the roadway. Eventually, Dr. Braddock had his house set back from the road. Across the Rancocas Creek on the left hand side is H.B. Ivins Blacksmith and Horseshoeing Shop. (Courtesy of Bob Duerholz.)

In revolutionary times, Main Street was known as the "Great Road." In the early 1800s, the New Jersey road system consisted of private lanes, slightly larger local roads, and public great roads that were links from county seats to industries, such as lumber, glass making, and iron works. Tuckerton Road was another "Great Road" traveling through Medford. It went from Camden to the seaport of Tuckerton. (Courtesy of Beverly Mickle.)

This view of South Main Street looking north shows a woman looking out from her columned porch and a store offering ice cream nearby. The building with the overhanging metal roof is Ed Warner's Hardware Store. The columned home still remains today. (Courtesy of the author.)

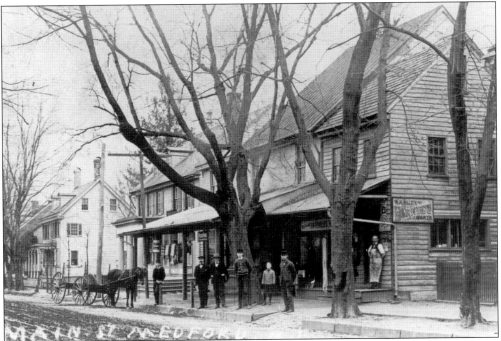

The building on the right is the William Allen Harness Maker Store at 24 South Main Street in 1905. Located next door is Ed Warner's Hardware Store, and beyond that is the columned house shown in the photograph above. Howard Friend is standing in front of the tree, and William N. Allen, the store owner, is on the porch at right in the apron. (Courtesy of Beverly Mickle.)

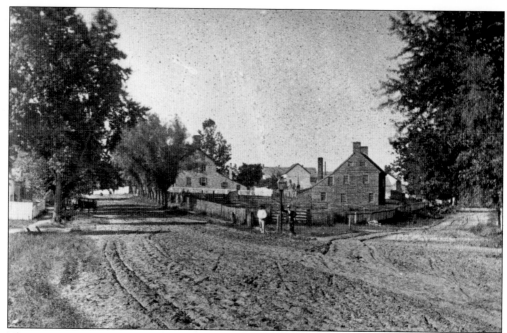

This picture, taken from a stereo view card, shows a rutted South Main Street on the left and the fork with Oliphant's Mill Road, now Mill Street, on the right in 1872. In the background is the area known as Glass Hill, where the glass works factory and the homes of the workers were located. Inside the fork today is Hewitt's Auto Body Shop. (Courtesy of Beverly Mickle.)

The Samuel Jones Farmhouse, shown in 1910, is one of the earliest built on Main Street. Located at the northeast corner of South Main and Coates Streets, this house remains a testament to when Medford was mostly farms. When it was built, farmland spread out behind the home. (Courtesy of Beverly Mickle.)

This daguerreotype, one of the oldest photographs of Medford that was probably taken in the 1860s, shows an unidentified couple in their horse and buggy riding on North Main Street around where the Lamb's Garage building is now located. The house in the background, located on Broad Street, was the private school where Milton Allen taught before he became the principal of the Filbert Street School. (Courtesy of Beverly Mickle.)

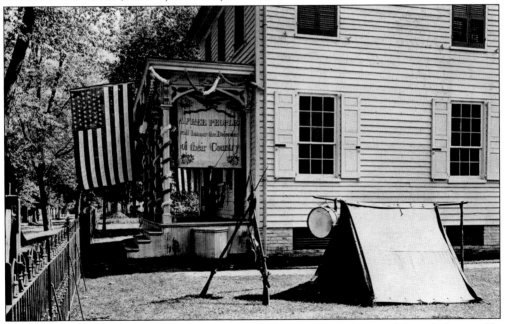

Capt. Elwood H. Kirkbride's house was located on the corner of Filbert and Branch Streets. He served in the 23rd Regiment New Jersey Volunteers in the Civil War. He returned to Medford and served as Burlington County surrogate. On the Fourth of July, he set up his old tent and surrounded it with flags. He died a month after this July 4, 1908, photograph. (Courtesy of Beverly Mickle.)

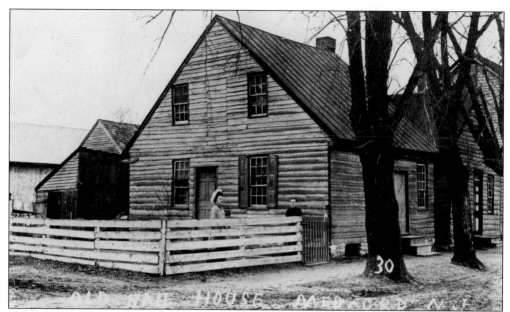

The Nail House, built by Mark Reeve, was first located at the corner of Main Street and Friends Avenue. When this photograph was taken in 1905, it had been moved to Cherry Street behind the Garwood House. The building was Mark Reeve's first store. Reportedly, it is also the place where the first machinery for the mass production of headed cut nails was produced in America. He failed to patent the process, and others have received credit. The Nail House on Cherry Street was moved in the mid-1960s to the Jennings Farm, where is stands today in an enlarged version. (Courtesy of Beverly Mickle.)

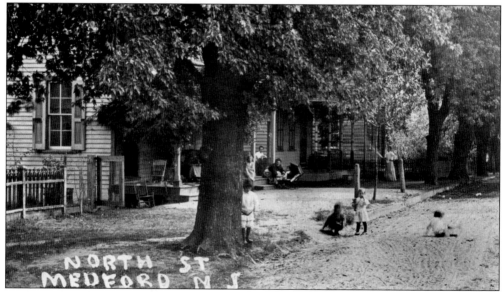

Kids are shown playing with their parents watching on North Street in 1910. The photograph identifies them as the children of Howard Crispin. According to the *Encyclopedia of Children and Childhood in History and Society*, the 10 most popular games from October through May 1904 were: playing with fire, craps, marbles, hopscotch, leapfrog, jump rope, baseball, cat (hitting and catching a stick), picture-card flipping, and tops. (Courtesy of Beverly Mickle.)

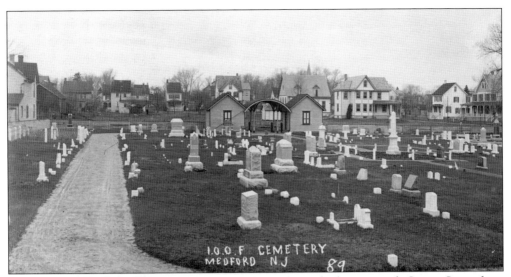

The Independent Order of Odd Fellows Cemetery is shown looking towards Coates Street from a lane inside the cemetery. The gatehouse at center was constructed in 1888 and is considered in the stick architectural style. Many Civil War veterans are buried in the cemetery, such as William Hewitt, who was involved in the Battle of Gettysburg. Many early residents of Medford are buried in the cemetery, including members of the Shontz family, the Braddock family, Milton Hannah Allen, and Elizabeth Cowperthwait. There is a similar entrance gate outside the Tabernacle Cemetery across from the town hall. (Courtesy of the Medford Historical Society.)

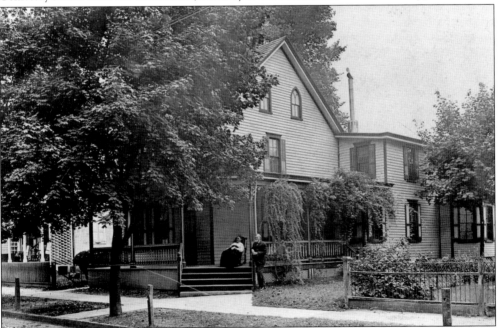

Milton and Mattie Allen are pictured at their home located at 30 Branch Street. In 1864, at the age of 16, Milton Hannah Allen started teaching at the Eastern School, where he was paid 3¢ per student per day. In the 1860s, he opened a boarding school on Broad Street and then at 19 Branch Street. He was both the principal and the janitor. He became the first principal of the Filbert Street School, and it is said that he designed it. (Courtesy of Beverly Mickle.)

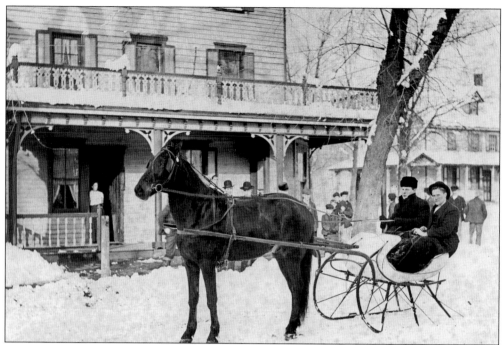

In 1910, transportation on a snowy winter day included a horse and a sleigh instead of a carriage. A crowd watches from inside and outside the Indian Chief Hotel on Main Street as Edwin Rogers (left) and Red Thompson head out of town on Union Street. (Courtesy of Beverly Mickle.)

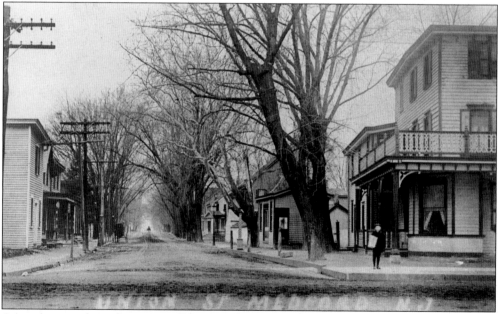

A newsboy stands on the corner of Union and Main Streets selling papers in front of the Indian Chief Hotel in 1905. Most likely he is selling copies of the *Central Record* newspaper. Founded in 1896 as a weekly in Medford, it also covered news in Shamong, Mount Laurel, Evesham, Southampton, and Tabernacle. Still in operation, it is the oldest newspaper in Burlington County. (Courtesy of Beverly Mickle.)

The Village Farm, located at 51 Union Street, was built for Jonathan Haines in 1760. At one time, this property included the entire north side of Union Street. In 1925, it belonged to Ephraim Gill, who also owned a farm in Haddonfield. Recently, it was owned by Ephraim Tomlinson, the former mayor of Medford, and his wife, Alice. (Photograph courtesy of Mary Bauer.)

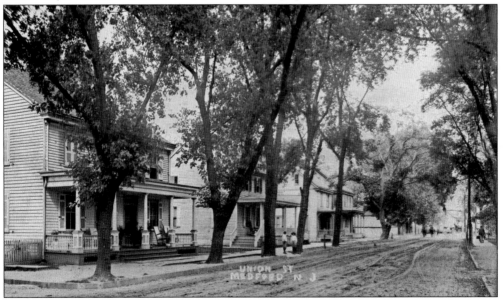

Union Street was not always the busy street it is now. Friends Avenue was the main roadway from Main Street to Hartford Road when the village was established and when the Friends Meetinghouse was built in 1814. But the constantly muddy road, due to passing through a low area near the Jones Farm, made the farmers change the course of the roadway to where it intersected with Union Street. That is why the rear of the Union Street Meeting House faces Union Street. When it was built, it faced Friends Avenue, the main road. (Courtesy of Beverly Mickle.)

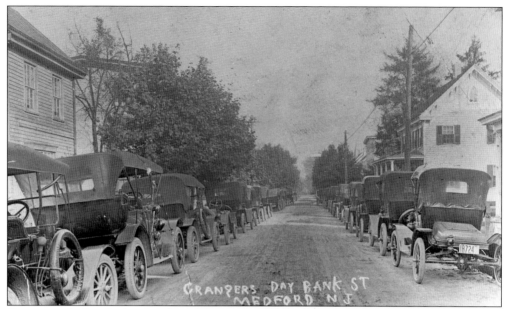

Cars are parked on both sides of Bank Street for Grangers Day in 1913. The National Grange of the Order of Patrons of Husbandry, commonly known as the Grange, was a fraternal organization for farmers. Founded in 1867, it is the oldest agricultural organization in America. The Grange and the church were the centers of social life for farmers. Albert Kirby headed the Medford Grange in the early 1900s. There was also a Grange hall in Vincentown. The Grange hall at 25 Bank Street is now the home of Medford Lodge No. 178 of the Free and Accepted Masons. (Courtesy of Beverly Mickle.)

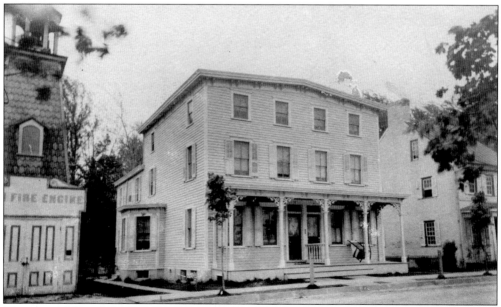

This view of the south side of Bank Street includes the Union Fire Company firehouse. Built in 1872 at 28 Bank Street, the firehouse was the second in the township and was in use until 1913. It housed a ladder wagon and was one of the tallest buildings in town with its unique tower containing a bell. The Philip Scott house is at right. (Courtesy of the Medford Historical Society.)

30

The Lawrence Webster House, located at 4 Bank Street, was built in 1810 on the corner of Main and Bank Streets as a store and home. It was moved when the Burlington County National Bank was built. Located behind the bank building, the Lawrence Webster House was torn down in 1964 to make room for an addition to the bank. Signs in the window say "Boots & Shoes." (Courtesy of Lois Ann Kirby.)

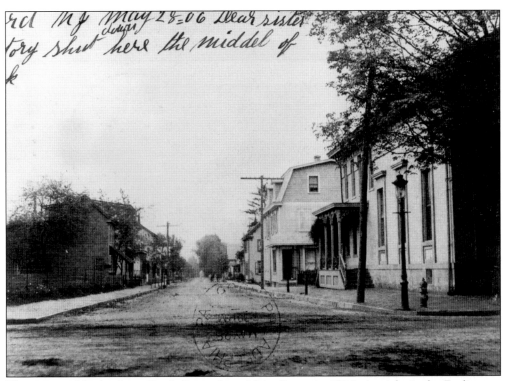

This postcard looks down Bank Street from Main Street in 1906. At right is the Burlington County National Bank building, with the Lawrence House behind it. The empty lot at left was used for various town events from circuses to rallies. Note the fire hydrant at the right corner. The Medford Water Company started placing hydrants about the town beginning in 1895. (Courtesy of Beverly Mickle.)

Built around 1870, the homes on Trimble Street, then known as Shipping House Street, were provided by the glass company and rented to the workers for $1.50 to $2.50 per month. Water was carried into the homes from three outdoor common pumps, but when a case of typhoid developed, the town decided to pipe in water. (Courtesy of the Medford Historical Society from the Clyde LeVan Collection.)

This Sears Roebuck house, the only one in Medford, is located at 13 Branch Street. Albert and Belle Ballinger built it in 1911. All the materials for the home were shipped from the Midwest on two freight cars to the Mount Holly, Lumberton & Medford Railroad station just blocks away. Mae Novelle (Ballinger) presently lives in the house, in which she grew up. (Courtesy of Mae Novelle.)

The home of Joseph Evans sits on the corner of Branch and Charles Streets. He and his wife lived in the right side of the twin house. To the right down the dirt road is the two-story Jerome Jennings cranberry packinghouse, which was built in 1870. Charles Street was named after one of Jerome's sons. The packinghouse is now Cranberry Hall, the Medford senior citizens center. (Courtesy of the Medford Historical Society.)

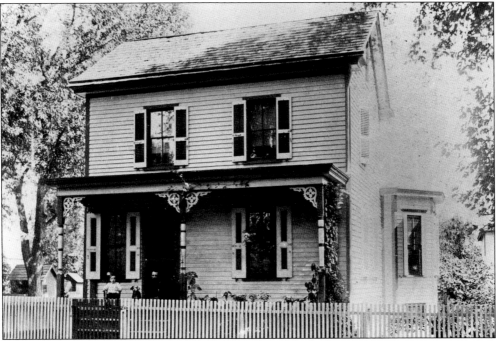

William Friend and his son Howard sit on the front porch of their home at 17 Filbert Street with their dog in 1896. The home, on the corner of Filbert and Mulberry Streets, was built in 1842. Young Howard Friend married the girl next door and eventually moved to Bordentown. In 1955, Everett and Beverly Mickle purchased the house from Everett's mother, who was born in the house. The Mickles collected everything to do with Medford. They preserved many of the photographs that appear in this book. (Courtesy of Beverly Mickle.)

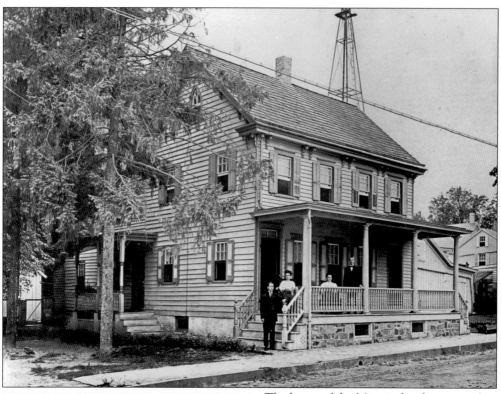

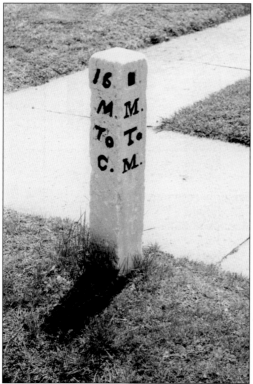

The home of the Mingin family was at 16 Bank Street, shown in 1910. Pictured are, from left to right, Lawrence, Anna, Mary, and Reeve Mingin. According to longtime resident Fred Atkinson, Bank Street was the only street in Medford that had a sewer line. It ran down to a sediment bed at the end of the street near Haines Creek. Reeve Mingin was a teacher in Sunday school at Medford Methodist Episcopal Church. Lawrence Mingin served as Burlington County clerk and was appointed to the New Jersey State Board of Utilities in 1919. (Courtesy of Beverly Mickle.)

Near the curb at 68 Union Street is this stone mileage marker. One side lists 16 miles to Camden from Medford and the other side lists the unknown miles to a town marked M, which could be Marlton or Mount Holly. The marker was placed at this location by Andrew Brown, who salvaged it around 1960. This marker at one time could have been located on the corner of Union and Main Streets. (Courtesy of the Medford Historical Society.)

Two

COMMERCE

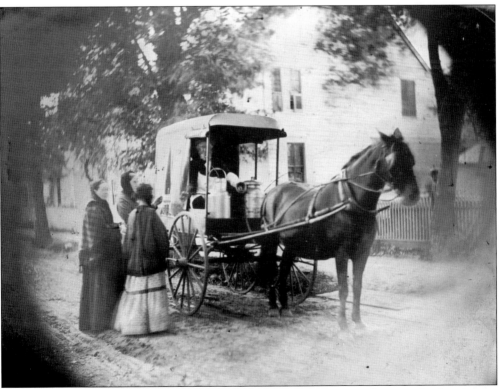

In one of the oldest photographs in the Mickle collection, women gather outside their homes on Union Street to purchase milk from milkman John Wright in 1870. Wright delivered milk throughout the village from the metal containers inside the horse-drawn wagon. Most of the milk produced from the many dairy farms in the township was shipped by train to Camden and Philadelphia. (Courtesy of Beverly Mickle.)

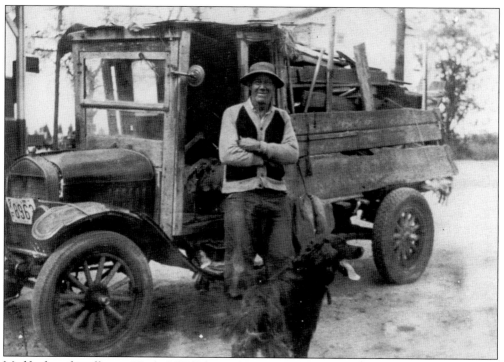

Medford trash collector "Porky" William DeMore stands by his truck at Cross Roads in 1937 with his Ford Model T truck. He picked up trash only for those people who paid him. Garbage, usually food items, was collected separately and sent to local piggeries. During the Depression, most items that are now considered trash were recycled. DeMore collected metal, rubber, glass, and wood and probably sold the items to scrap dealers to earn his living. He lived on Trimble Street. (Courtesy of Beverly Mickle.)

Mail carrier Frank Branson delivers mail to a house at 95 South Main Street in 1916. The 1910 census lists him as a full-time mail carrier living on Main Street with his wife, Martha, in the Village of Medford. The mail arrived in town by rail and was sorted at the post office on North Main Street. (Courtesy of Beverly Mickle.)

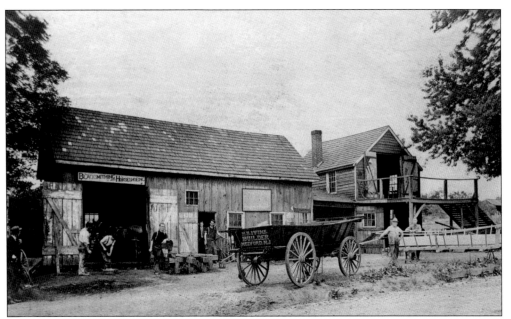

The buildings of H.B. Ivins, horseshoer, blacksmith, builder, and wheelwright (above) are shown with some of the workers performing their jobs. The complex was located on South Main Street near the bridge over Haines Creek. After Ivins moved, the site on Main Street became the Gick and Bingemann Bus Garage. The Pinelands Branch of the Burlington County Library is now located on the site. Ivins moved his business to Branch Street around 1908, as shown in the photograph below. Mae Novelle talks about going past Ivins's blacksmith shop around 1918 and using his pump to get a drink of water on her way to the Filbert Street School. Around 1937, Clifford Atkinson Sr. bought the property on the corner of Branch and Filbert Streets and tore down the decrepit building. (Both, courtesy of the Medford Historical Society.)

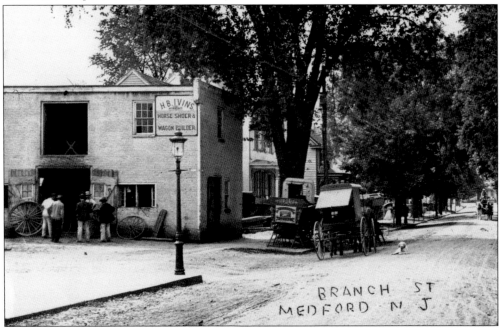

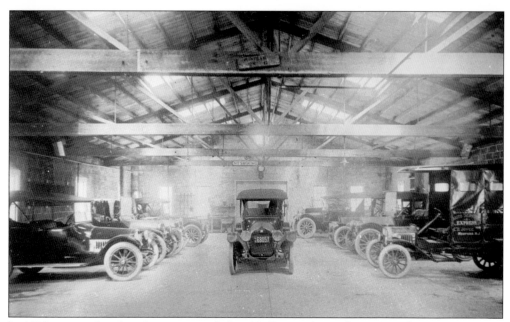

In 1916, cars are lined up for repair inside Lamb's Garage, located at 49 North Main Street. At right is the truck of Eayre Joyce, who ran a one truck Jitney Service and Express Delivery Service in Medford. Lamb's Garage also had buildings on Charles Street. The 1915 Main Street building was expanded in 1923 and housed the showroom and main repair facility. Lamb's employees are pictured standing outside an expanded garage in 1940. Included in the picture are Al Godfrey, John Jennings, Bill Wilkins, Lester Gestringer, Eckert Thompson, Ida McClain, Sis Smith, and Bill Mingin. (Both, courtesy of Beverly Mickle.)

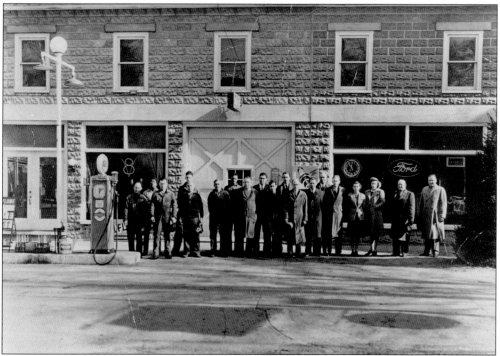

South Medford Store
General Merchandise

Clover Bloom, Full Cream Butter	lb. 27c
Gorton's Ready-to-Fry Codfish Cakes	2 for 25c
Salad Bowl, the Perfect Salad Dressing	20c

Full Pint Jar

Free Running Salt	Full Cream Cheese
3 Boxes for 10c	lb. 18c

Sunsweet Prunes, Soft and Meaty	2 lbs. 15c
Best Michigan Soup Beans	3 lbs. 10c
Tartan Fancy uncoated Rice	2 for 15c

Full lb. Pkg.

Gold Medal Cake Flour	Snappy Boy Coffee
Pkg. 25c	lb. 17c

Baker's Shredded Cocoanut, Moist	lb. 20c
4 xxxx Sugar	3 for 20c
Tartan Pure Vanilla, Large Bottle	22c
Reg. 3 for 10c Cocoanut Cream Eggs	4 for 9c
Tartan Evap. Milk, tall can	3 for 20c
Dutches Royal Anne Cherries, Big Can	25c

Selected Fruit

These Prices in Effect March 17, 18, 19
ELMER H. CARIGAN

Standing behind the counter inside the former Star Glass Company store on South Main Street are Edward and Edith Wills. In 1946, he took over the operation of the store from his uncle Elmer Carigan and changed the name to Wills General Store. He ran the store for more than 50 years until it closed in 1999 when he retired. When it was the Star Glass Company Store, workers at the plant would buy all their groceries there using credit books. The store clerk would punch out the amount of the purchase, and the company paymaster would deduct that amount from the worker's weekly pay. A handbill with a list of prices from the early 1900s is shown including some Easter items. (Right, courtesy of the Mark Scherzer Collection; below, courtesy of Jean Hinchman and Marvin Wills.)

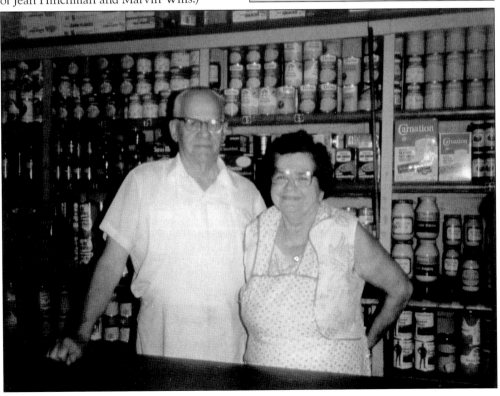

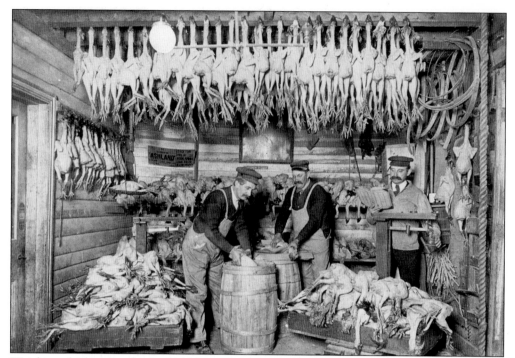

Weighing chickens inside the S.T. Haines Poultry Dealer shop at 35 South Main Street in 1909 are, from left to right, Pemberton Griscom, Thackara Haines, and Walter Stackhouse. They would clean and weigh the chickens purchased from local farmers, put them on ice, and ship them by train to Philadelphia. The store also sold flour, seed, salt, and ice. (Courtesy of Beverly Mickle.)

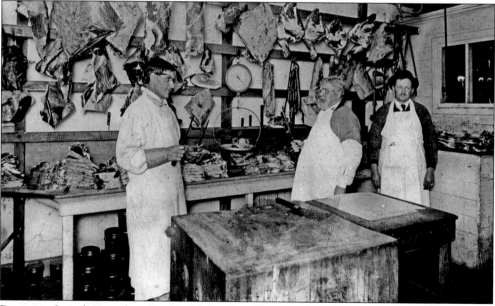

Preparing for a day's work at Braddock's Butcher Shop are, from left to right, John Haines, Josh Braddock, and Harry Reeve. The store was located next to Braddock's Tavern at 37 South Main Street. Cattle from the surrounding farms supplied meat to the butcher, who sold his products to residents and to the tavern next door. (Courtesy of Beverly Mickle.)

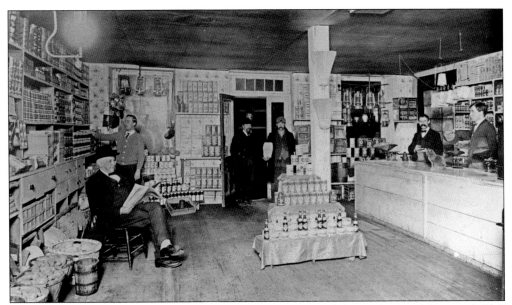

Inside Stacy Prickett's Store at 26 South Main Street are, from left to right, Israel Garwood, Cliff Prickett, John Mickle, Nick Holman, Charles Griscom, and Howard Friend. The photograph was taken around 1909 on a Saturday night. Often, the store was open till 10:00 or 11:00 p.m., and it served as a gathering place for people in the village. (Courtesy of Beverly Mickle.)

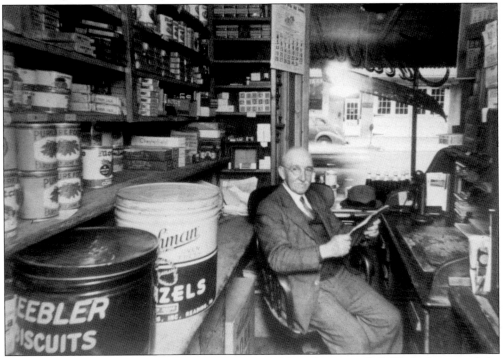

J. Maurice Garwood sits inside his store at 29 South Main Street in 1942. He had operated the store since 1895, when he purchased the business from Frank Haines after serving as a clerk for many years. He was one of Medford's leading merchants, also serving as director of the Burlington County National Bank of Medford for over 12 years. (Courtesy of Beverly Mickle.)

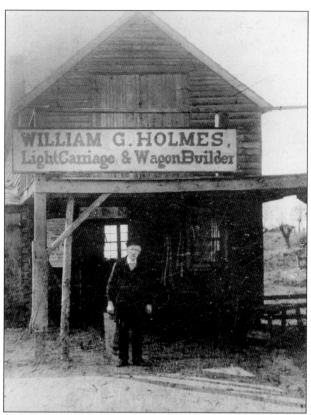

William G. Holmes, a light carriage and wagon builder, stands outside his shop in 1890. In the early 1900s, H.B. Ivins took over the operation and expanded the business on South Main Street near the Rancocas Creek. The Pinelands Branch of the Burlington County Library now sits on the site. (Courtesy of Beverly Mickle.)

Jay Friant (left) stands inside his barbershop on Union Street around 1910. He was also a special police officer in the town for many years. Mae Novelle, a 95-year-old Medford resident, remembers her and her mother, Belle Ballinger, having their hair cut at Friant's Barbershop. They both wore their hair short, and not many women had short hair at the time. (Courtesy of Beverly Mickle.)

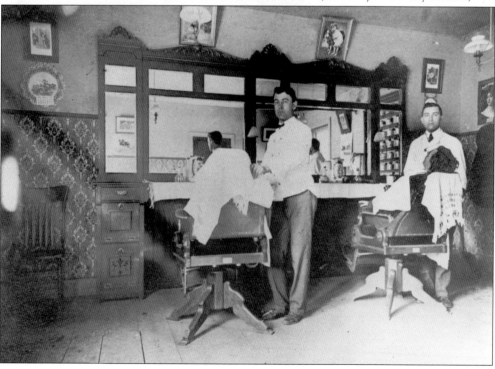

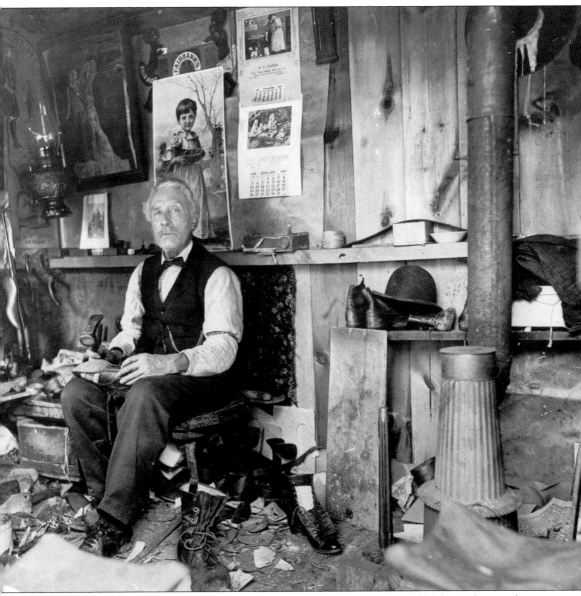

Shoemaker John Carrigan sits working inside his small shop in January 1908 (according to the calendar on the wall behind him). His shop was located behind 83 South Main Street, where he repaired and made shoes for the locals since there was no shoe store in Medford at the time. (Courtesy of Beverly Mickle.)

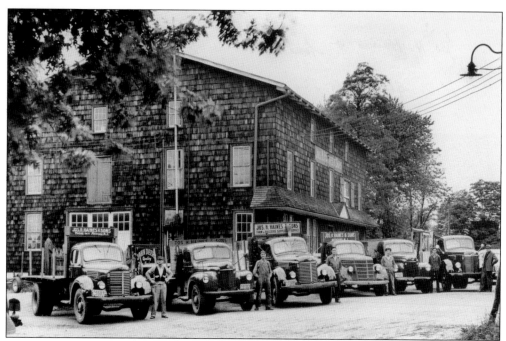

Employees of Joseph H. Haines & Sons pose by their trucks outside the store around 1948. Standing are, from left to right, Ben Whitcraft, Frank Souders, Bill DeMore, Harry Barnes, unidentified, and owner Everett Haines. The company sold farm implements, tractors, and building supplies, as shown in the advertising photograph below from 1908. The Haines complex, located on what is now Tidswell Street, encompassed a huge area near the Mount Holly, Lumberton & Medford Railroad terminus. Its chief competitor was Kirby Bros. on Main Street. (Both, courtesy of Beverly Mickle.)

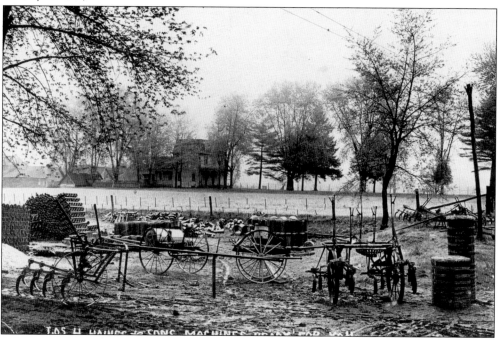

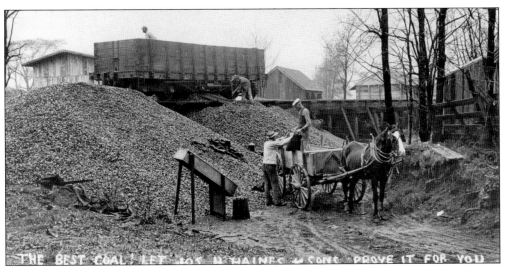

The Joseph H. Haines & Sons Company sold coal, as shown in this advertising card. The coal was unloaded from train cars and onto horse-drawn wagons in 1909. Anthracite coal was the basic fuel for home heating. Cooper White shovels coal from on top of the coal pile while Watson Stewart and Walter Allen bag the coal. The photograph below shows the inside of the office of the Joseph H. Haines & Sons Company in 1948. Pictured are, from left to right, two unidentified women, Howard Roberts, Gloria Oakman, Maurice Haines, and Everett Haines. Maurice and Everett Haines lived next door to each other on North Main Street near Route 70. Medford Township honored the businessmen by naming the sixth-grade center after them. (Both, courtesy of Beverly Mickle.)

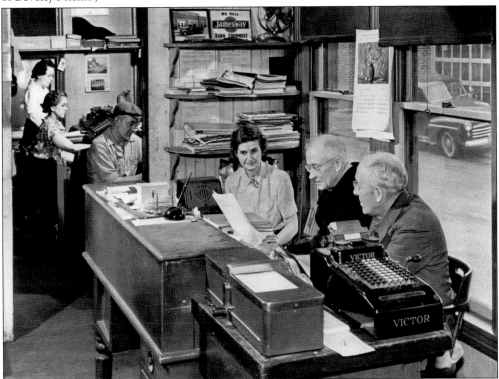

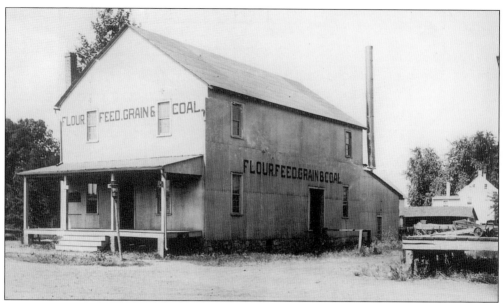

The Kirby brothers, Charles H. and William G., began their operations at Kirby's Mill on Church Road in 1877. Looking to expand and move into town, they purchased the building at 67 North Main Street (above) in 1896. After installing milling equipment in the building, they continued operations there. They expanded further by selling coal, flour, grain, and farm equipment, as shown below. Kirby Bros. is the longest continuously operating family business in Medford. (Above, courtesy of Lois Ann Kirby; below, courtesy of Beverly Mickle.)

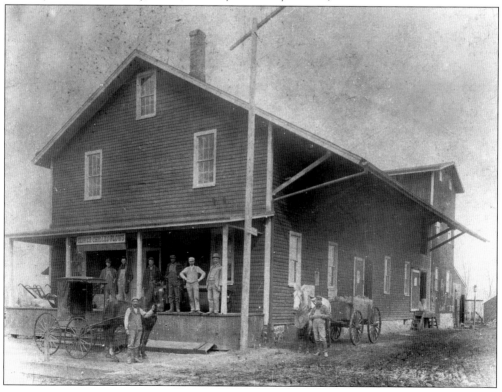

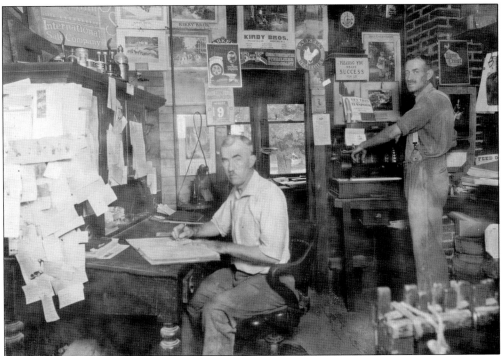

Inside the office of Kirby Bros. Feed Store in 1945 on North Main Street are Albert F. Kirby (left) and Eli Wells. It was said of Eli that he was "so honest that if he had to cut a grain of corn in half so not to cheat the customer or his employer, Eli would do it." He worked at the store for 35 years and was known for his whistling. Kirby Bros., known for its advertising calendars, distributed them to every house in town. C. Engle Kirby recalled that the only time he was allowed into Braddock's Tavern was once a year when he delivered a calendar. Driver Leon Gaskill waits below for the start of the Halloween parade in 1900 with a Kirby Bros. decorated float. (Above, courtesy of Lois Ann Kirby; below, courtesy of Beverly Mickle.)

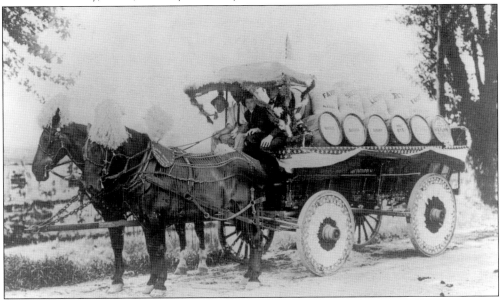

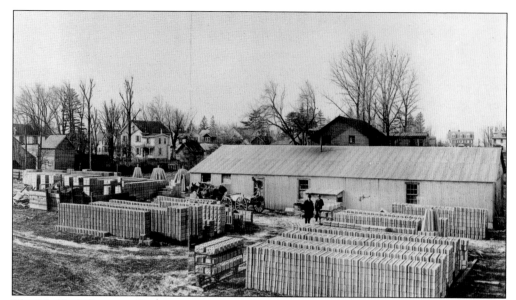

The Medford Concrete Company was a huge firm located on Branch Street near the terminus of the Mount Holly, Lumberton & Medford Railroad and the Philadelphia, Marlton & Medford Railroad lines. The firm was located near the Joseph Haines & Sons Company. The company manufactured cement blocks, pipes, and concrete staves for silos. Many of the concrete silos in the surrounding area were built with concrete from this factory. (Courtesy of Beverly Mickle.)

The Powell Knitwear building, constructed in 1913, was also located near the railroad tracks on Charles Street. The sign above the loading dock door advertises "Girls Wanted Paid While Learning." It is the original building of the Medford Knitwear Company. The Lavinsky brothers, Samuel, Irving, and Moses, purchased the former hosiery mill in 1936. The company expanded to property they owned on Route 70 in 1968 when it merged with Warnaco. (Courtesy of Beverly Mickle.)

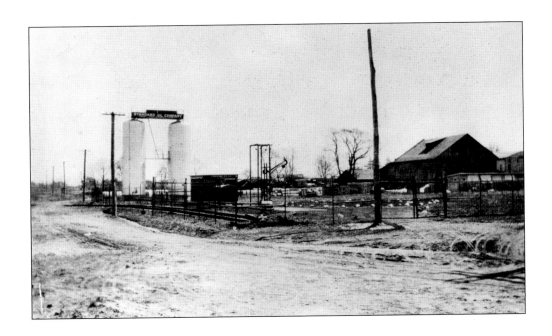

Standard Oil located a new plant near Broad Street in Medford in 1923. The plant was in the rear of the Joseph Haines & Sons Company lumberyard. A railroad siding from the Mount Holly, Lumberton & Medford railroad served the plant. Driver Andy Brown, below, stands by his Standard Oil delivery truck in 1918. It was the second truck that Standard Oil had in South Jersey. The truck held 618 gallons of fuel serving homes in Medford and the surrounding towns. The plant eventually closed in 1937. (Both, courtesy of Beverly Mickle.)

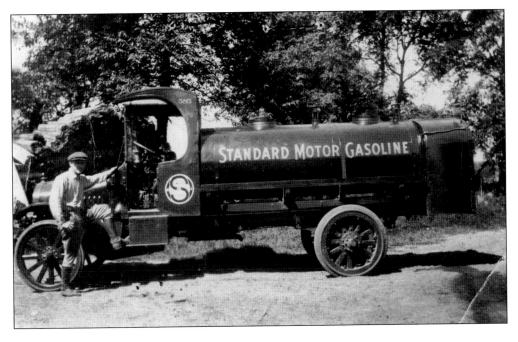

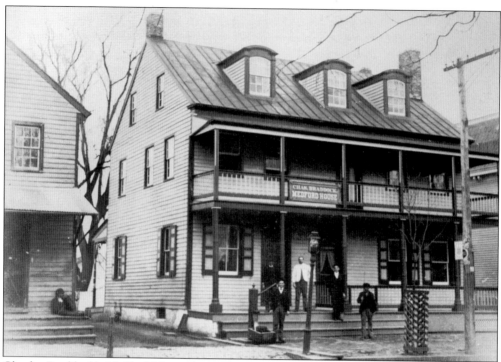

Charles Braddock's Medford House, located on South Main Street, was one of the few taverns located in Medford in the early 20th century. The 1876 map of the town shows the property as the W.H. Clover Medford Hotel. Charles Braddock purchased the hotel and the surrounding sheds and horse stables and put his name on the hotel. Later, he changed the name to Braddock's Tavern. The building at left is the butcher shop owned by Josh Braddock. Below, owner Charles Braddock stands at his bar in 1920, served by bartender Clint Prickett. Smiling behind Charles Braddock is Ed Garron. The sign above the bar states "Beer on Tap, Not on Tick." (Above, Courtesy of Beverly Mickle; below, courtesy of Larry DeVaro.)

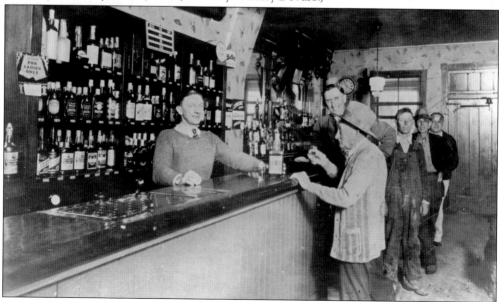

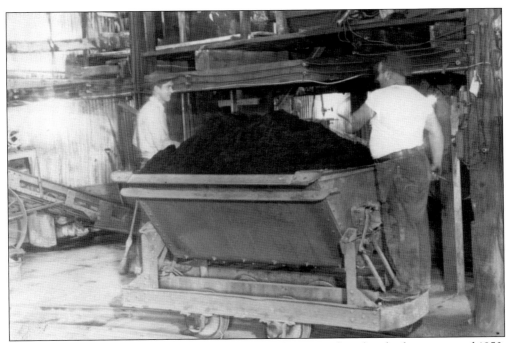

Zeolite Chemical Company workers unload processed greensand marl at the factory around 1950. Marl was a huge commercial product in South Jersey. It was used by farmers as a fertilizer and soil conditioner. In 1873, South Jersey operators shipped out almost 135,000 tons of marl, and about the same amount was dug by local farmers for their own use. Marl was later used as a water softener and was commercially mined and sold by the Zeolite Chemical Company. The aerial photograph shows the expanse of its operation on Fostertown Road. Incidentally, the adjacent town of Marlton is named after the material. (Both, courtesy of the Medford Historical Society.)

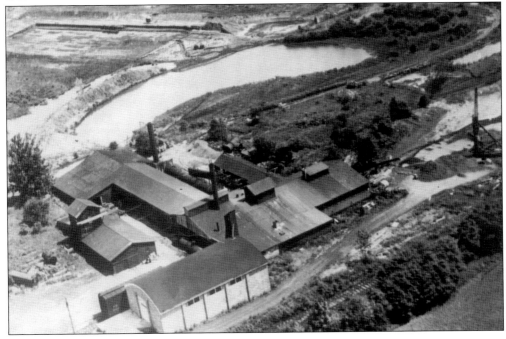

House painters Walter McClain (left) and William Griscom walk down Union Street in 1905 carrying their supplies, including a ladder, paint, and wallpaper. They were partners for seven years from 1904 to 1910. After they separated as business partners, they remained as painters and competed for the same business in town, as seen in front-page advertisements in the *Central Record* newspaper from April 26, 1912. Below, from left to right, painters William and Walter McClain, George Mingin, and Tom Fowles are shown at work painting the side of a house. (Both, courtesy of Beverly Mickle.)

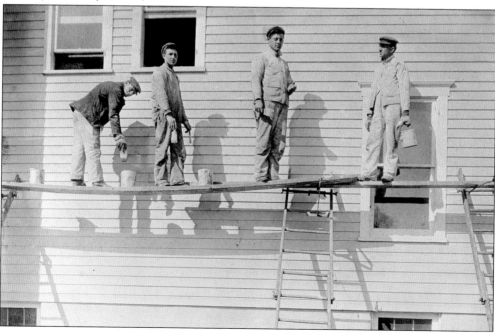

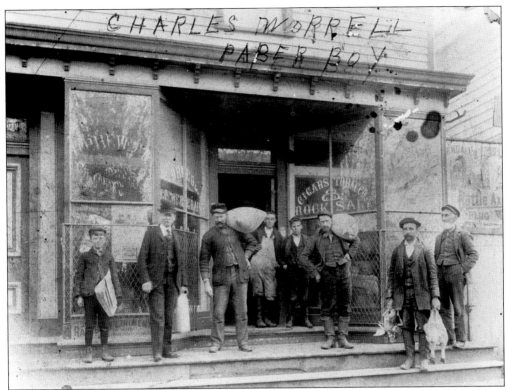

Standing outside the H.P. Hewitt Store at 35 South Main Street in 1905 are, from left to right, paperboy Charles Worrell, Charles Storey, Walt Stackhouse, Bill Griscom, unidentified, Joe McQuiqq, and two unidentified men. An optician store is currently located in this building. Paperboy Charles Worrell grew up to be a talented baseball player and well-respected coach. Medford dedicated a field in his honor on Fostertown Road. (Courtesy of Beverly Mickle.)

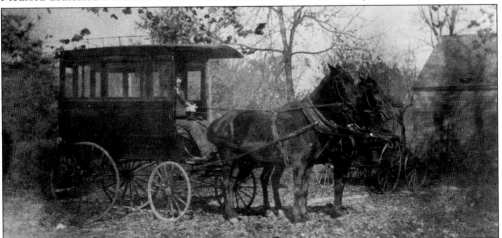

Medford jitney driver Howard Homan is shown with his team of horses and extended carriage in 1910. He was the taxi cab driver of his day, making his rounds from the Philadelphia, Marlton & Medford train station to the Mount Holly, Lumberton & Medford train depot. He also carried families and luggage throughout town and to other local towns. His services were also used for weddings and funerals. (Courtesy of Beverly Mickle.)

Outside Ed Warner's Store at 20 South Main Street, owner Ed Warner (left) and Cleveland Hagerthy unload baskets from a horse-drawn carriage in 1909. Warner's store sold everything from hardware and farmer's and builder's supplies to stationery, sporting goods, phonographs, music, toys, blankets, stoves, and ranges. It also sold a wide range of automobile and bicycle supplies. (Courtesy of Beverly Mickle.)

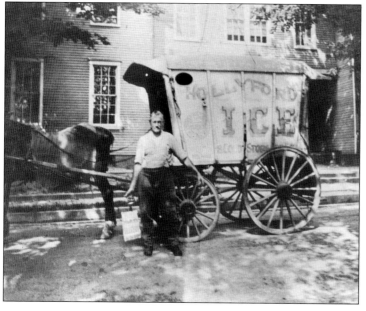

Walter Stackhouse makes a delivery for the Mount Holly, New Jersey–based Hollyford Ice Company to the Filbert Street School in 1910. Ice was important in the days before refrigeration. Many homes and farms had ice houses or places in their basement to store ice. Many commercial companies used the lakes outside Medford to cut ice. They then stored it and sold it in the heat of the summer. (Courtesy of Beverly Mickle.)

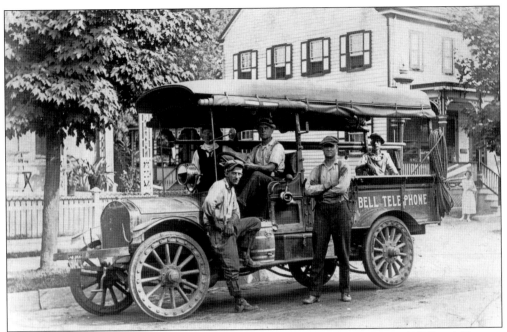

A Bell Telephone truck sits at the intersection of Main and South Streets in 1915. Frank Davis is leaning against the running board. Morgan Evans is standing in the street. Lawrence Mingin is sitting in the back of the truck. Resident Maude Riley Montgomery is standing on the sidewalk to the right. Most homes did not have phones, but most businesses did. William Cooper had the first telephone in Medford installed in his hardware store. (Courtesy of Beverly Mickle.)

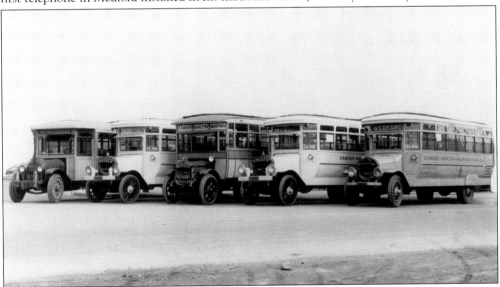

Shown in line are buses in the Camden, Marlton & Medford Bus Line owned by Gick & Bingemann in 1924. Most of the buses carried US mail and 25 passengers along the same route as the former Philadelphia, Marlton & Medford train line. The buses' bodies were made by, from left to right, Kuleman, Mack, Schwartz, Mack, and Mack. The bus garage was located on South Main Street where the Pinelands Branch of the Burlington County Library is now located. (Courtesy of Beverly Mickle.)

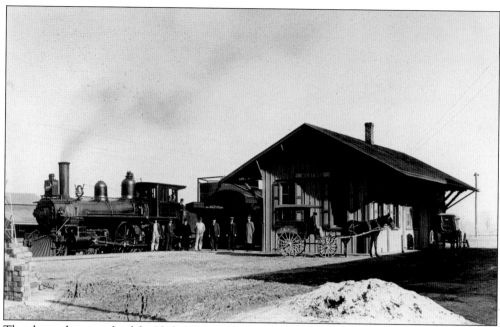

The above photograph of the Philadelphia, Marlton & Medford train station in 1905 shows train engineer Eli Thomas and conductor Chris Shingle outside the North Main Street depot with a "P" engine. Also shown is Medford hack Howard Homan waiting with his carriage. In the 1910 photograph below, milk cans are unloaded from the train and are picked up by local dairymen. The first train bound for Camden each morning hauled fresh milk to the city. The line was put into operation in October 1881 and carried passengers, mail, coal, agriculture products, and building materials to and from Philadelphia. Milk service on the line was discontinued due to motor truck around 1925. (Both, courtesy of Beverly Mickle.)

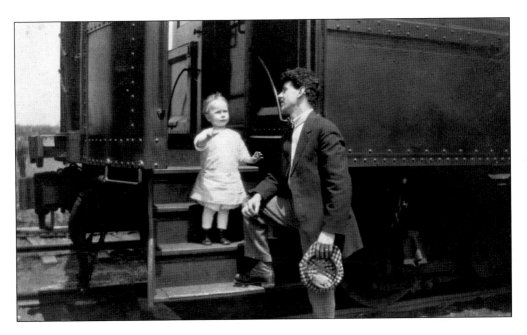

Two-year-old Mae Ballinger is greeted by her father, Albert Ballinger, as she arrives at the Philadelphia, Marlton & Medford Train Station in 1914. Passenger service on the line was not a big money maker; the railroad depended on the shipment of produce and products to make a profit. Often during gunning season, hunters would ride the train out to Medford because open fields were only a short walk away from many of the stations. The last passenger train to run on the Medford branch completed its trip on September 24, 1927. Below, the train engineer is standing next to a No. 14 class D1 engine built in Altoona, Pennsylvania, and is photographed behind the Philadelphia, Marlton & Medford train station in Medford in 1887. (Above, courtesy of Mae Novelle; below, courtesy of the author.)

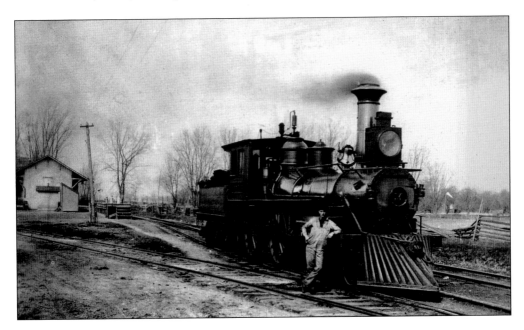

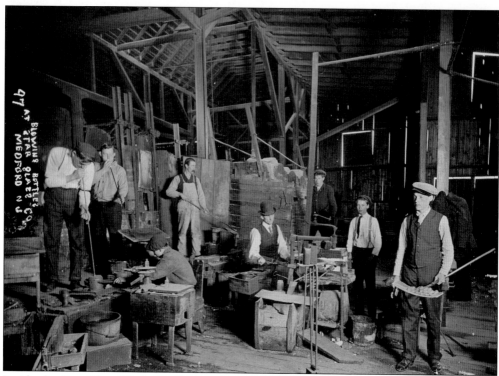

Inside the Star Glass Works, gaffers, mold boys, and glassblowers work together to produce handblown bottles in 1910. Above, glassblower Edward Schemilia (left) blows air down a pipe to enlarge the molten glass inside the mold. In the almost 90 years of its existence, the glass factory went through several owners. In 1894, one of the blowers, John Mingin, bought the factory with two other partners and formed Star Glass. According to *The Glass Gaffers of New Jersey*, "at one time the men on the 5 p.m. to 2 a.m. shift became noted for their group singing while they worked. On a balmy evening the townspeople would drop in and listen to glassworks harmony." Below, many of the glass blowers are photographed with their blowpipes. (Above, courtesy of Beverly Mickle; below, courtesy of the Medford Historical Society.)

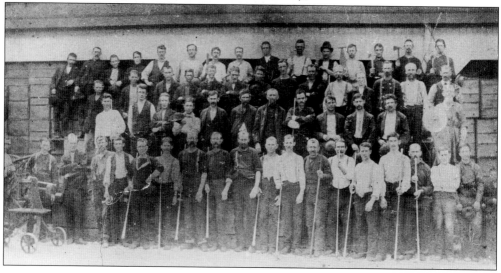

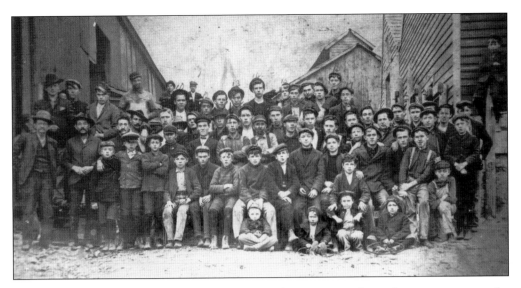

A group portrait of some of the employees at Star Glass Company shows that many appear to be young boys. Edward Wills, who later owned the Star Glass Company Store, said he was a carry-in boy at the factory when he was 12 years old working alongside his father. At its peak, the company employed 250 people. Star Glass had 10 shops with five men to each shop working around the clock. Below, Star Glass Works employees are shown working inside the high-ceilinged factory in 1910. Some of the men identified are Everett Thackery, Bill Robinson, Frank Branson, Ralph Johnson, Bert Marles, Ed Wills Sr., Red Thompson, Dan Thackery, and Rube Cosaboon. (Above, courtesy of Brenda Parks Morris; below, courtesy of Beverly Mickle.)

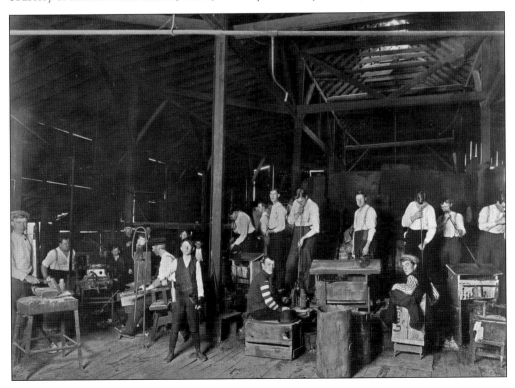

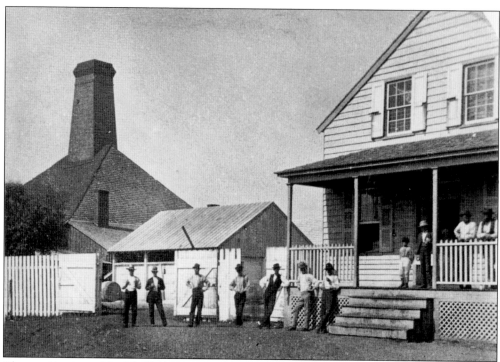

The outside view of the Medford Glass Works Company in 1872 shows the company store at right and the towering smokestack of the factory at left. After the factory closed in 1923, the chimney stood until a windy day in the 1940s, when it toppled over with a huge crash. The factory, open nine months a year, produced windowpane glass, wine bottles, flasks, perfume bottles, soda bottles, pickle jars, and flat-paneled bottles. They also produced the first lock-top catsup bottles for the Campbell Soup Company in Camden, New Jersey. Below, the last owner and manager of the Star Glass Works, John Mingin, stands on the steps of the company store in 1895 with his hands on his hips. (Both, courtesy of Beverly Mickle.)

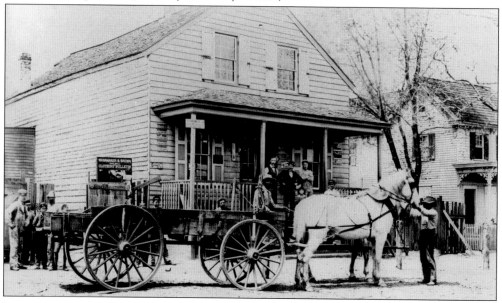

Three

MILLS

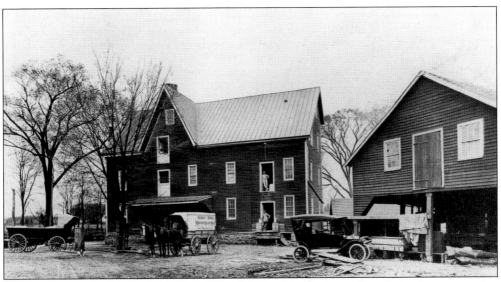

This 1912 view of Kirby's Mill on Church Road shows the transition of one form of transportation to another. An automobile sits outside the sawmill to the right, while George Powell drives the team of horses in the company wagon. Standing in the doorway on the second floor of the gristmill is co-owner Charles Kirby. Kirby's Mill was just one of many saw and gristmills located in Medford along the Rancocas Creek. Mills and farms were among the first businesses in the young township. (Courtesy of Beverly Mickle.)

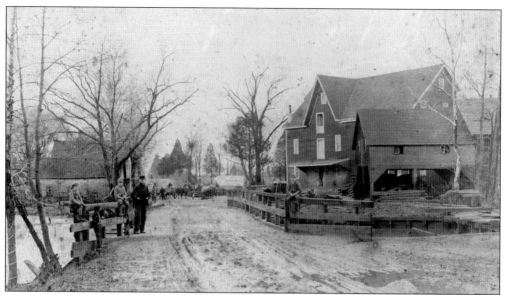

This 1905 image of Kirby's Mill looks west across the Rancocas Creek towards the sawmill at right and the taller gristmill behind it. In the early days, the cut timber would float down the Rancocas Creek to Lumberton, where it would be loaded onto ships and barges. Under the Kirby ownership, the sawmill produced 18,000 to 20,000 board feet of lumber. The gristmill, operating 24 hours a day, was grinding 50 barrels of wheat, rye, and buckwheat flour a day under the Crown, Luxury, and Success labels. (Courtesy of Betty Joyce Wright.)

Across from the Kirby's Mill complex on Church Road is the 225-year-old Nehemiah Haines House. It was also known as the "miller's house," because many of the owners of the mill lived there. The Kirby family lived in the house in the late 1800s and early 1900s. At left is Ella Norcross Kirby (mother) with her daughters Edith (center) and Anna. (Courtesy of Lois Ann Kirby.)

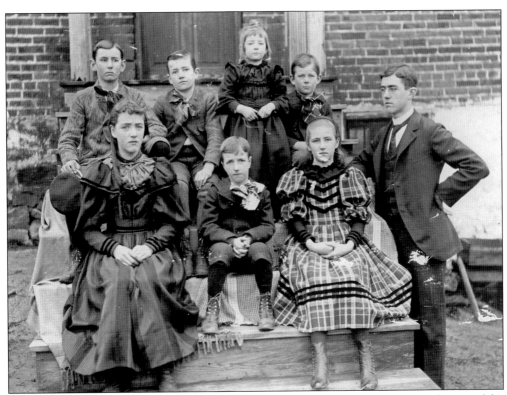

In a family photograph from around 1895, members of the Kirby family sit on the back steps of the miller's house, located on Church Road across from the mill. Pictured are, from left to right, (first row) Helen Burton Kirby (1881–1940), William Thomas Kirby (1887–1918), Mabel Henlick Kirby (1884–1968), and Albert Frank Kirby (1876–1945); (second row) John Norcross Kirby (1876–1946), George Henry Kirby (1882–1953), Anna Rebecca Kirby (1890–1975), and Charles Wright Kirby (1886–1946). Missing is Edith Violet Kirby (Joyce), who was born later that year. They are the children of William Gaskill Kirby and Ella Frances Norcross. William Kirby had purchased the mill in 1877 and added a cider mill and carding mill. (Courtesy of Lois Ann Kirby.)

Four-year-old Grace Ballinger, on the bicycle, and three-year-old Bertha Ballinger, in the wagon, pose in the front yard of the miller's house near Kirby's Mill in 1932. In the background is a Ceresota Flour advertising sign that was painted on the storage building across from the mill. Since purchasing the building, the Medford Historical Society has recreated the sign on the side of the same building on Church Road. (Courtesy of Grace Ballinger Haines.)

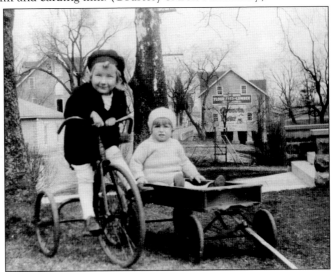

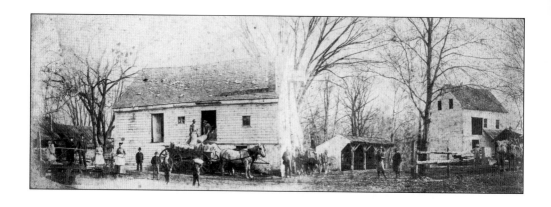

In the panoramic photograph above of the Oliphant's Mill complex, men load bags of flour from the gristmill onto a horse-drawn wagon around 1880. The saw and gristmill, established in the early 1700s, was located at the end of Mill Street, where it extended across the Rancocas Creek to where Hartford Road ends at Taunton Road. In the tintype photograph below, John Ford stands next to his horse and cart filled with bags of flour at Oliphant's Grist Mill. John Ford worked for John Wilkinson at the mill. In the background is the stable that stood behind the mill. (Both, courtesy of Beverly Mickle.)

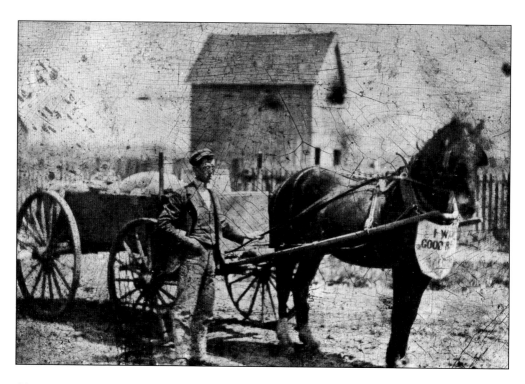

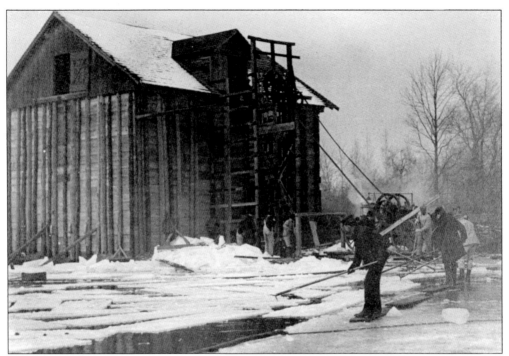

Workers move thick blocks of cut ice on the lake towards the storage house at Oliphant's Mill in the early 1900s. It took about a dozen workers and one week's work, day and night, to fill the icehouse. In the white overalls, third from right, is Frank Naylor. In the foreground is Charles Hewitt. One of the workers in the photograph is Walt Thackey, who later formed Hollyford Ice in Mount Holly. Oliphant's Mill ceased its sawmill operations in 1906, close to when the photograph below of the sawmill was taken. (Both, courtesy of Beverly Mickle.)

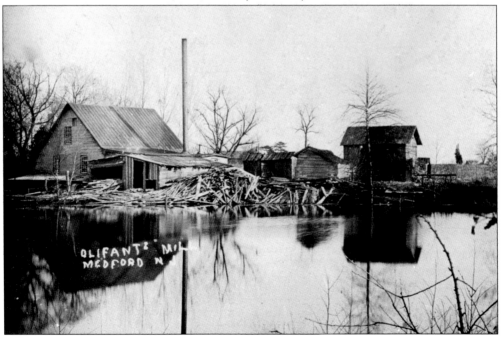

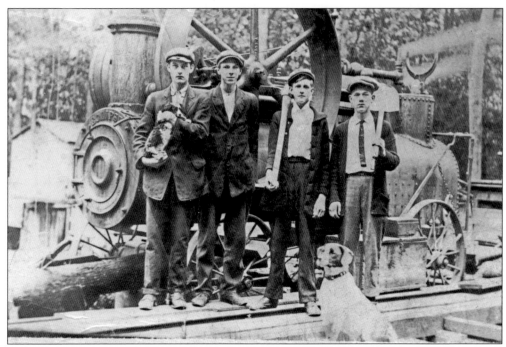

A group of sawmill workers, mostly young boys, poses with their dogs while taking a break at a mill east of Medford. They are probably working at Jonathan Peacock's Mill, located near the area of Chairville. It operated from 1790 until it was destroyed by fire on April 17, 1894. Some of the products produced from the steam turning mill were chair legs, rungs, and spindles from maple trees cut in the area. (Courtesy of the Milton Allen School Archives.)

The Ballinger Saw Mill was located on the north end of Lower Aetna Lake south of Tabernacle Road. It was started in 1766 when Charles Read needed lumber for Etna furnace. In 1821, the mill was purchased by Thomas Ballinger, and it remained in the hands of the Ballinger family for more than a century. In 1926, Laura Ballinger sold most of the property to Clyde Barbour and Leon Todd for the development of Medford Lakes. (Courtesy of Beverly Mickle.)

Buzby's Mill was part of the Charles Read estate in 1784. In the early 1800s, it was purchased by Jabez Buzby, but it was closed down in the late 1800s. The area was then converted into cranberry bogs. In 1926, the YMCA purchased the property to become Camp Ockanickon. The only building remaining on the site was converted to a camp building. (Courtesy of the YMCA Collection.)

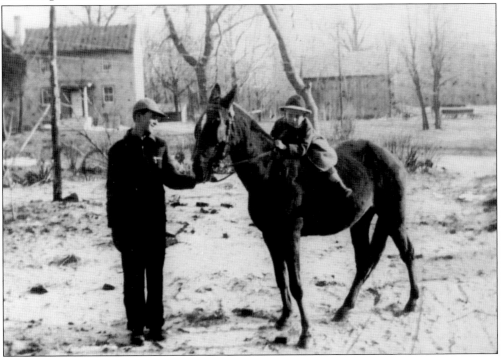

A boy straddles a horse at Christopher's Mill, which is located north of Tuckerton Road and west of the bridge over the creek that forms Medford's western border. Joseph Hewlings, one of the first settlers in Burlington County, built the sawmill in 1741 and a brick house in 1743 that still stands today. John Christopher married Hewlings's daughter and eventually turned to cranberry farming. (Courtesy of Beverly Mickle.)

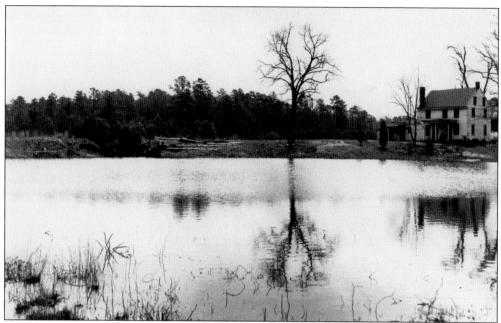

In 1818, Barzillia Branin built a gristmill, home, and outbuildings where Birchwood Lakes is now located. Barzillia died in 1822, and his two sons, Eli and Francis, operated the mill until 1855. It was then purchased by James Snyder, who was the miller during the last years of the Branin ownership. Nothing remains of the mill or the house, which was photographed in 1953. (Courtesy of Beverly Mickle.)

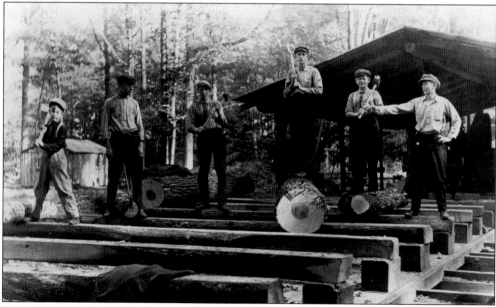

Cutting timber into railroad ties was the work of these men and boys at Peacock's Mill in the early 1890s. In the photograph are, from left to right, Charles Newman, John Kelly, Joe Phiffer, Kingdon Vaughn, unidentified, and Sam Bakely. Train service arrived in Medford in 1869 from Mount Holly, and these railroad ties were probably used as replacements on that line or the Philadelphia, Marlton & Medford line, which was built in 1881. (Courtesy of Beverly Mickle.)

Four

AGRICULTURE

Cranberry pickers Joe Sweeten (left), unidentified (center), and Herb Sweeten stand with the results of a day's worth of picking: boxes filled with berries at Chairville. The cranberry industry was the next big industry in Medford. With the timber supply exhausted, the water from the Rancocas Creek that had turned sawmill wheels now supplied fresh water for the production of cranberries. (Courtesy of Beverly Mickle.)

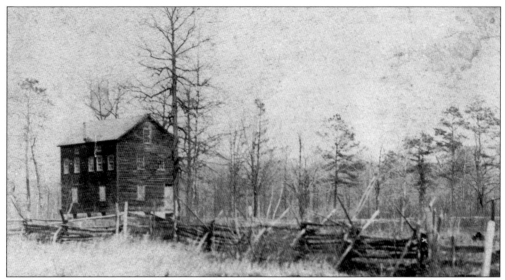

The Christopher's Mill Cranberry Packinghouse was an example of a former sawmill that underwent conversion in the late 1800s due to the popularity of the fruit. After sawmill operations ceased, the surrounding lowlands were converted into cranberry fields. Dry harvesting was the main way to pick the berries at the time. Wet harvesting didn't come into use until later in the century. (Courtesy of Beverly Mickle.)

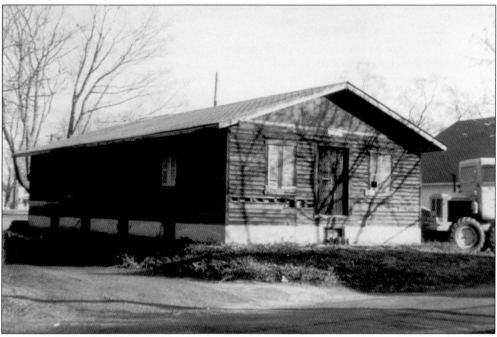

Shown is the Jennings Cranberry Packinghouse on Charles Street in 1964 as it was being converted into Cranberry Hall, now a senior citizens center. The former two-story building, shown in photographs in the early 1900s, was used by the cranberry industry because of its proximity to the railroad lines. Medford was known as the center of the cranberry industry because of the two rail lines. The berries were shipped all over the United States and Canada. (Courtesy of Beverly Mickle, photograph by Everett Mickle.)

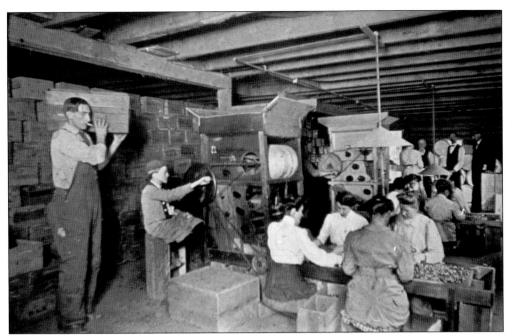

Workers sort cranberries at Knight's Cranberry House on Charles Street north of Branch Street around 1915. There were about 10 or 12 cranberry packinghouses in Medford at the beginning of the 20th century. The native fruit was sorted, packed, and stored in barrels, half barrels, and quarter barrels. In the late 1800s, Joseph Hinchman of Taunton was the largest cranberry grower in the United States, owning 3,000 acres. Everybody in Medford was buying land in the area to convert to bogs, including the areas around what are now Oakwood Lakes, Birchwood Lakes, and Centennial Lakes. The bogs in the Centennial area employed 350 to 500 people in the picking season. One of the labels used on a Medford cranberry barrel is shown below. (Above, courtesy of Beverly Mickle; below, courtesy of the author.)

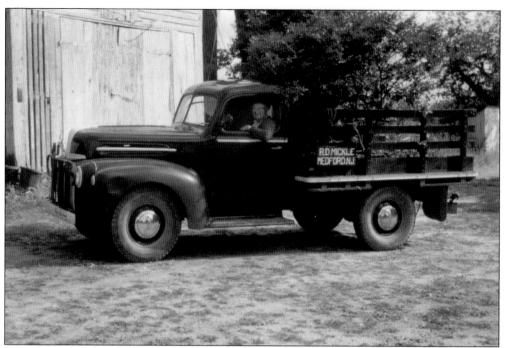

Roy Mickle, whose family farmed peaches, tomatoes, and strawberries on the land located north of Route 70, sits in his truck in 1962. He sold the property to a developer later that year. Ten generations of his family lived on the land that is now part of Medford Leas. (Courtesy of Beverly Mickle.)

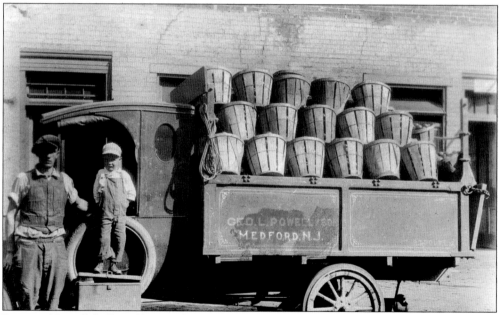

Raymond Powell (left) and his son Leroy stand beside the truck owned by George Laning Powell with a load of tomatoes. Tomatoes were a huge crop in Medford area farms. They were either delivered to the Campbell Soup Company in Camden or to the Stokes Cannery in Vincentown. (Courtesy of Benda Parks Morris.)

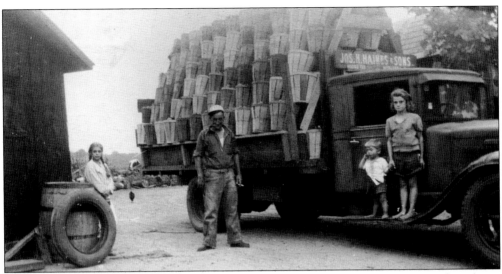

On August 20, 1942, at Henisee's Village View Farm on Wilkins Station Road, a rented truck was loaded with 377 stacked baskets of Jersey tomatoes. That day, the truck would make two trips, carrying seven tons of tomatoes each trip. In this photograph are, from left to right, Floss Henisee, driver Larry Baines, Joe Henisee, and Alice Henisee. (Courtesy of the Henisee family.)

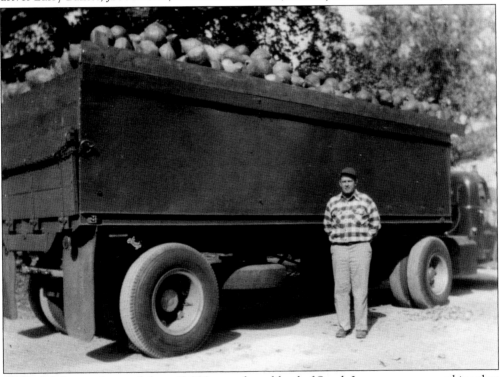

Clifford Atkinson Jr. stands by a 40,000-pound truckload of South Jersey–grown pumpkins that he delivered to Mrs. Smith's Pie Company in Pottstown, Pennsylvania in 1950. Atkinson, who lived on Filbert Street, owned a trucking company that often delivered locally grown produce to factories and farm stands. Pumpkins are still a big crop in the Medford area today. (Courtesy of Fred Atkinson.)

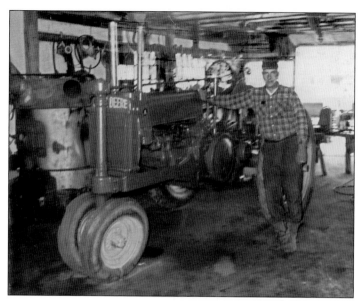

Farmer William Johnson stands beside his John Deere tractor in the late 1950s. Moving the family farm from Burlington to Medford in 1953, the Johnsons started out with 73 acres and farm 110 acres as of 2012. Peter and Eric Johnson have taken over the duties of the farm and have expanded the operation to include pick-your-own and other family-friendly activities at the corner of Hartford and Church Roads. (Courtesy of the Johnson family.)

The Samuel Gager Homestead on Stokes Road is shown in the early 1900s. The farm was located where the TD Bank is now, near the intersection of Stokes Road and Dixontown Road. Margaret Gager stands behind the fence with sons Theodore and Mancill Gager in front. (Courtesy of Ed Gager.)

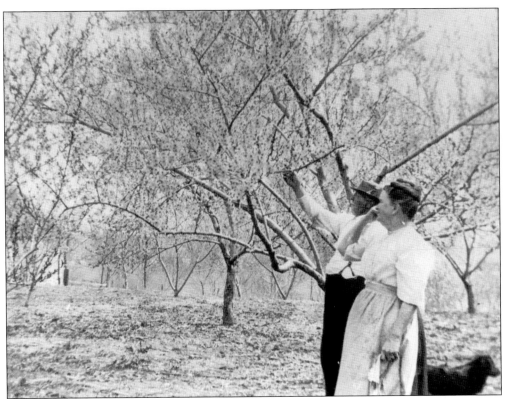

Around 1910, Peter and Margaret Mickle examine the peach trees in bloom at the Locust Hill Fruit Farm located between the tracks of the Mount Holly, Lumberton & Medford Railroad and the Rancocas Creek. Ed Gager, who was raised in Medford, remembers canoeing along the Rancocas, stopping at the farm, and eating peaches in late summer. (Courtesy of Beverly Mickle.)

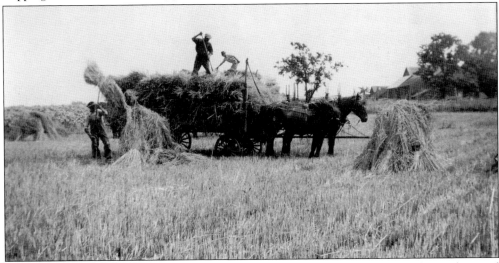

Farmhands gather hay on Prickett's Farm on New Freedom Road near Chairville Road around 1930. Many dairy farms were located on the north side of Medford, and hay, rye, and silage were a important crops for area farmers to store and use on the farm. (Courtesy of the Medford Historical Society.)

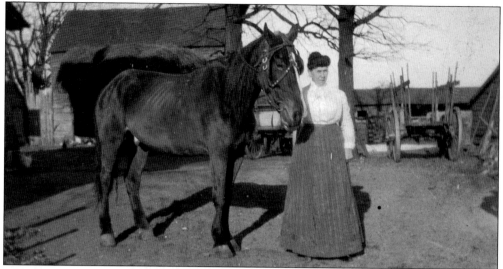

Margaret Small Gager stands with her driving horse at the family farm on Stokes Road, south of the village. The Small family of Burlington County first settled in this region in 1750. She was well known for her snapper soup, made from snapping turtles found in local ponds. She died in the flu epidemic that swept through the area in 1920. (Courtesy of Ed Gager.)

Robert Carns stands with his sled next to the family cow Bessie. Many families, although they weren't dairy farmers, owned a few cows to supply the dairy needs of the family. In the background is the family house, Hickory Farm. It was built in 1800 and was owned by the Carns family in 1940. The frame building was possibly constructed by Thomas Wilkins, who built a brick home further back from Medford's Mount Holly Road. (Courtesy of Dale Carns.)

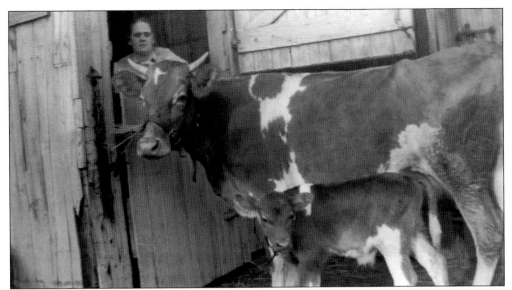

Bea Henisee stands inside the door of the barn with a cow and her calf outside on the family farm, located on Wilkins Station Road. The farm extended from Wilkins Station Road to the Mount Holly, Lumberton & Medford railroad tracks adjacent to the Mickle farm. Below, slaughtered hogs are tied up waiting to be butchered on the Henisee farm. Shelton Drayton, seen facing the camera, performed the service. He was the butcher at Casaboon's Meat Shop in the Cross Keys section of Medford. (Both, courtesy of the Henisee family.)

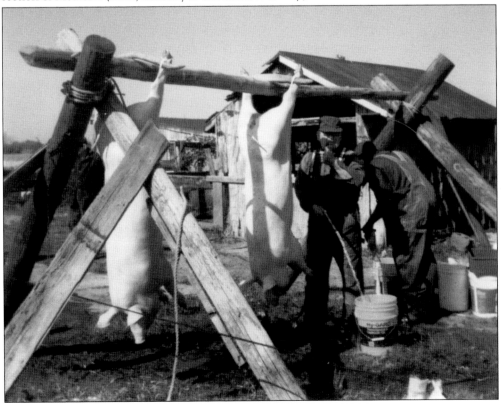

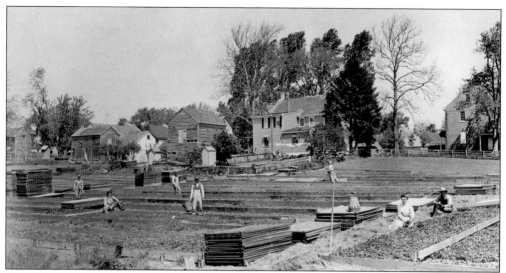

In 1905, Pemberton Griscom's sprawling plant business was located north of South Street. He supplied young tomato plants for farmers from Medford, Marlton, and Vincentown. Photographed are, from left to right, Harry Myers, Charles Sorden, Bill Griscom, Pemberton Griscom (with basket), Martha Griscom, Hannah Griscom, and Harry Carty. The Main Street Quaker Meetinghouse is at the upper right. The land is now part of the Independent Order of Odd Fellows Cemetery. (Courtesy of Beverly Mickle.)

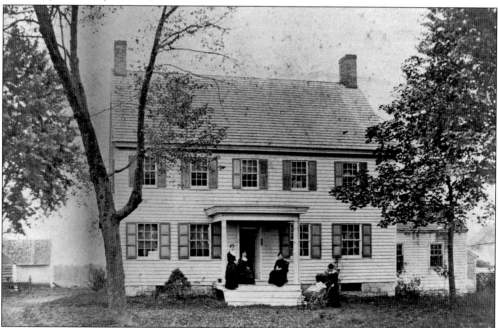

In 1883, the John R. Jones Farm, located at 86 Union Street, is shown with family and friends in front of the farmhouse. Photographed are, from left to right, Susan Swope, Sara Garwood (Lillie), Laura B. Jones, Bessie Jones, and Belle Cline in the carriage. The farm was later sold to the DeStefano family. The farm was once considered for the Lenape High School campus. Later, it was purchased by Medford Township, and it is now the home of Freedom Park. (Courtesy of Beverly Mickle.)

The John Mickle farmhouse, on the south side of Jennings Road, is shown in 1905. Many dairy and vegetable farms were located north of the Village of Medford. Various creeks ran through the area, including Sharp's Run Creek, which flowed beside the Mickle Farm. (Courtesy of Beverly Mickle.)

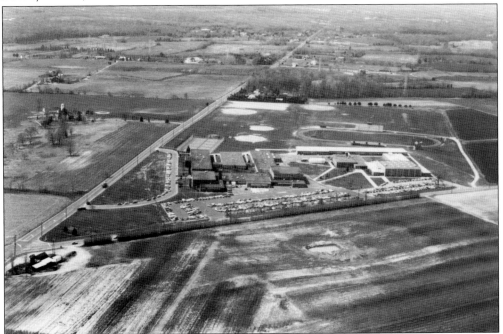

This aerial photograph from the late 1950s shows the farmland northwest of Medford Village. The William Johnson Farm is at the bottom of the photograph, and the William Jones farm is at left. Lenape High School, built in 1957, is in the center of the photograph. The Johnson Farm stand is shown in the lower left corner, at the intersection of Church and Hartford Roads, where it stands today. (Courtesy of the Medford Township Police Department.)

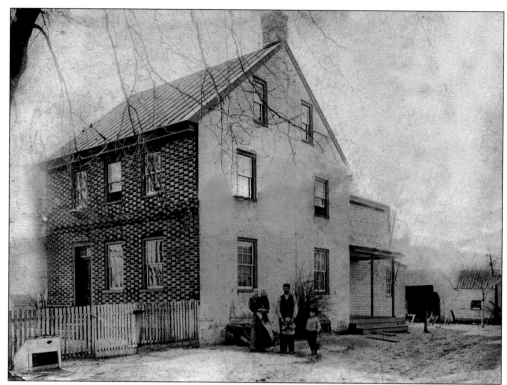

This 1790 farmhouse, located on Branin Road at the Chapel Avenue intersection, was built for John Peacock. He was the son of Adonijah Peacock, who died nearby in a black powder explosion in 1777 while making gunpowder for the Revolutionary War. Farmed for more than two centuries, the Adams family currently owns the property and runs the Flora Lea Equestrian Center. (Courtesy of Ed Gager.)

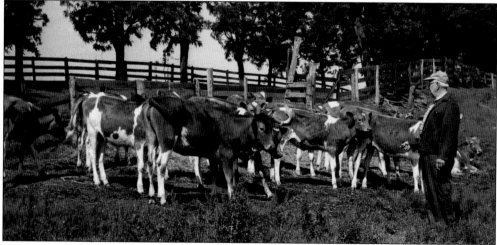

Albert H. Forsythe stands in the field among his prized Jersey cows at the Locust Lane Farm on Church Road in 1961. The Forsythe family was involved with many farm-related activities, including the county farm fair and the 4-H. Albert was also the father of US Congressman Edwin Bell Forsythe, who served the area from 1971 to 1984. (Courtesy of the New Jersey State Archives, Department of State.)

The Charles Hollingshead Home and Farm was located off Mount Holly Road heading out of Medford across Route 70. The springhouse (lower right) was used before the days of refrigeration. The small building was built over the source of a spring, and the constant cool water bubbling out of the ground kept perishable products from spoiling. The farm is now the Springhouse housing development. (Courtesy of Beverly Mickle.)

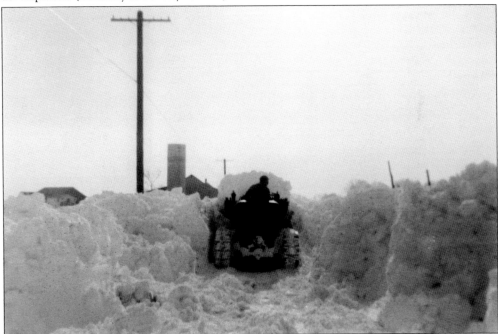

A huge snowstorm in 1958 blocked the entrance to the Henisee farmhouse on Wilkins Station Road. Known as the Village View Farm, it was sold in 1981 to Medford Leas, a Quaker retirement community, for its expansion. The silo in the background and one of the outbuildings are all that remain at the Wilkins Station Road entrance to Medford Leas. (Courtesy of the Henisee family.)

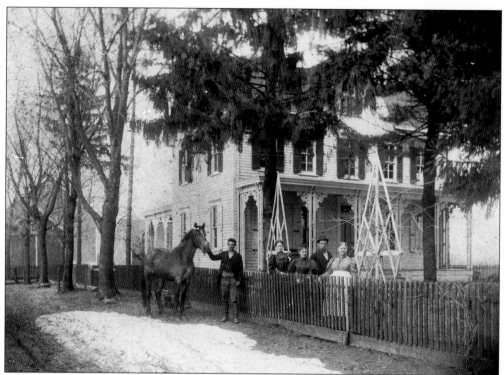

The Braddock Homestead, known as the Green Lawn Farm, was a dairy and crop farm built in 1863. It was located on the west side of Route 541 beyond the Everett and Maurice Haines School. The Medford School District purchased the property and used it as district offices for a number of years. It tore down the building in the 1990s. (Courtesy of Roberta Shontz.)

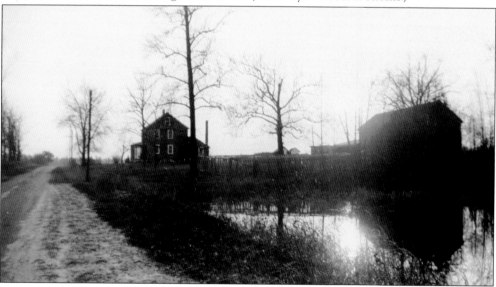

The Flemming Farm was located on Jackson Road south of Birchwood Lakes. This view from 1950 shows the reflection of the barn in Birchwood Lake. An advertisement from April 26, 1912, in the *Central Record* shows the dairy or stock farm for sale with good buildings included. (Courtesy of Beverly Mickle, photograph by Everett Mickle.)

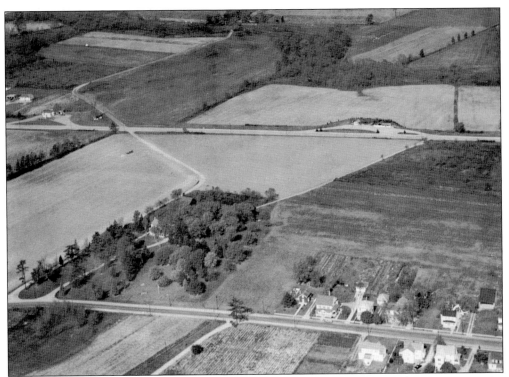

This 1950s aerial photograph shows the farms located north of Union Street (running across the bottom of the photograph). Jones Road, the S-shaped road at left, got its name because it ran from the John Jones Farm on Union Street to the William Jones Farm near Church and Hartford Roads. Route 70 is located in the middle of the photograph running parallel to Union Street. (Courtesy of Betty Trumbower.)

The farm of the late Dr. Edward Jennings is located off Hartford Road on his namesake road. Now owned by his descendents Sallyann Jennings and Mary Beth Melton, the preserved four-generation farm raises grass-fed cattle and free-range chickens. Dr. Jennings had the historic Nail House moved to his farm in the mid-1950s to restore and preserve it. (Courtesy of Beverly Mickle, photograph by Everett Mickle.)

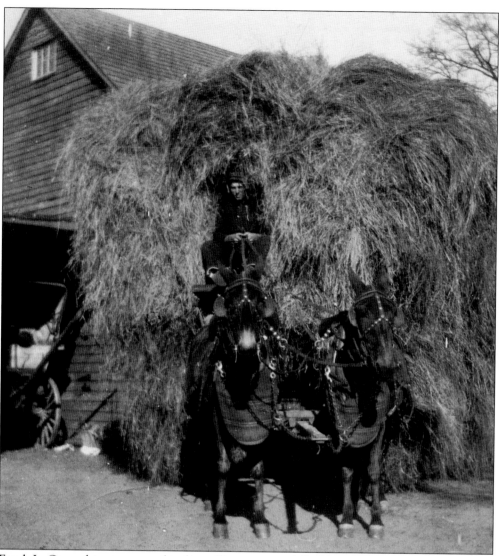

Frank L. Gager drives a team of mules pulling a wagon full of hay on the family farm in 1911. Frank Gager was a hay and horse dealer in Medford. The Gager family has been active in Medford organizations for generations. Lester Gager was hired to build the one room schoolhouse at Cross Keys in 1857 (opposite page). Mancill Gager, a pioneer in the building of log cabins in the area, built many of the homes in Medford Lakes. Leon Gager was the first police chief in Medford Lakes. Currently, Ed Gager is the president of the English Setter Club of America, based in Medford. (Courtesy of Ed Gager.)

Five

SCHOOLS

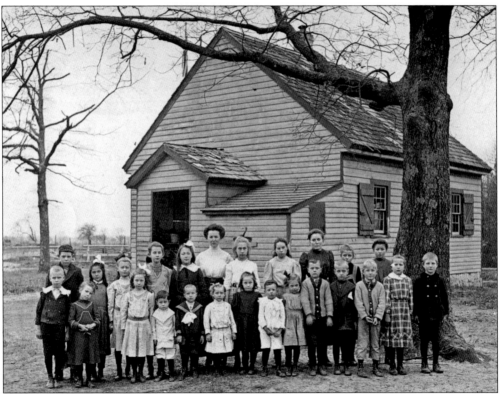

Medford photographer William B. Cooper took this Cross Keys School group portrait in 1907. Pictured are, from left to right, (first row) Carlton McElvee, Gertrude McElvee, Nola Hiles, Stanley Hiles, Laura Crispin, Frances Crispin, Mildred Hiles, Russell Shontz, Hilda Shontz, Charles Shontz, Arthur Crispin, Joe Anderson, Ella Marles, and Frank Marles; (second row) Albert Shontz, Ida Edelson, Sara Anderson, Lydia Anderson, Bella Edelson, teacher Helen Seiber, Elizabeth Marles, Mary Borton, Lizzie Schrieder, Mary Schrieder, and Leila Schrieder. (Courtesy of Beverly Mickle.)

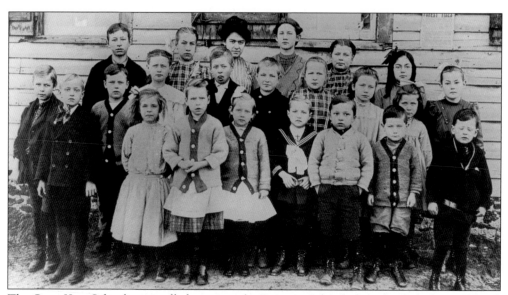

The Cross Keys School, originally known as the Fairview School, then the Oak Grove School, was built in 1857 by Lester Gager. The building was 26 feet deep by 22 feet wide, and the lumber for the school cost $9. Three generations of the Gager family, whose homestead was across the street, attended the school. In the photograph above, teacher Sara Davis stands in the back row, not much taller than some students. There is also a sign posted on the building warning of forest fires, since the school was located in a rural area. In the bottom photograph is the 1916–1917 report card for Leon Gager, whose teacher was Sara Davis. Note that the school was closed in September "on account of Infantile Paralysis." Infantile paralysis was another name for polio, a worldwide epidemic that mostly affected children and the elderly. (Both, courtesy of the Medford Historical Society.)

Medford Township Public High and Graded Schools, 1916 -1917

Report of *Leon Gager* 5th Year, *Cross Keys* School Department

NOTE---Subjects in which pupils are below grade at the beginning of the term are underscored in red ink.

Promotion depens on daily class work, written tests, habits of study and conduct.	Application in School	Reading	Writing	Spelling	Geography	Language and Composition	Grammar	Arithmetic	Physiology	U. S. History	Literature	Drawing	Scholarship Average	Conduct	Times Tardy	No. of Half Days Absent	Name of Parent or Guardian
SEPTEMBER	School closed on account of Infantile Paralysis																
OCTOBER	G	90	80	95	85	85		85	85	90			86⅔G		0	0	Mrs M Gager
NOVEMBER	G	90	80	95	85	85		85	85	90			86⅞G		0	0	Mrs M Gager
DECEMBER	G	90	80	95	85	85		85	85	90			86⅛G		0	0	Mrs M Gager
JANUARY	G	85	75	100	95	95		100	85	95			91⅞G		0	0	Mrs M Gager
FEBRUARY	G	90	80	95	85	85		85	85	90			86⅞G		0	0	Mrs M Gager
MARCH	G	90	85	95	85	85		85	85	90			87½G		0	0	Mrs M Gager
APRIL	G	90	85	95	85	85		85	85	90			87⅘G		0	0	Mrs M Gager
MAY	G	90	85	95	95	85		85	85	90			89 G		0	0	
JUNE	G	90	85	85	85	85		85	85	90			84⅘G		0	0	

Parents are requested to EXAMINE each monthly report, affix signature and return to teacher. Please give careful consideration to results marked U or below 70.

EXPLANATION OF MARKS.---100 or P. is Perfect; 90 to 100 or E. is Excellent; 80 to 90 or G. is Good; 70 to 80 or F. is Fair; 60 to 70 is U. or Unsatisfactory. Letters denote application in school work only.

Sara K Davis
Teacher

Merritt Jenkins Supervising Principal

86

The dilapidated Cross Keys School building is shown where the present-day McDonald's restaurant is located on Stokes and Dixontown Roads. The school closed in 1927 and over the years was used as a home, a store, and a farm market. When the property was sold to McDonald's in 1976, the community came together to save the one-room schoolhouse. The township moved the building to its present location on Mill Street that same year. The restoration was completed in 1985. The school is the township's only rural school building surviving today. (Above, courtesy of Beverly Mickle; below, courtesy of the Medford Historical Society.)

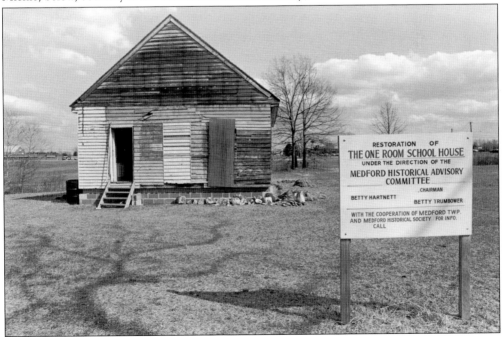

(Form A22—20M—4-1-12)

TEACHER'S CONTRACT

It is agreed between the Board of Education of *Medford Township* in the county of *Burlington* and *State of New Jersey* that said Board of Education has employed and does hereby engage and employ the said *Sarah K Davis* to teach in the *Cross Keys* public school, under the control of said Board of Education, for the term of *one* year from the *3rd* day of *September*, 1912, at the salary of $ *405.00* to be paid in *nine* equal monthly installments; *of $45.00 each*

that the said *Sarah K Davis* shall begin teaching on the *3rd* day of *September*, 1912; that the said *Sarah K Davis* holds a valid *3rd* grade *County* certificate to teach, issued in New Jersey, now in full force and effect, or will procure such certificate before the date she shall begin teaching, and that the date when said certificate will expire is the *1* day of *November* 19 *13*, and that said teacher, before entering upon the duties of such position, will exhibit *her* certificate to the *County* Superintendent of Schools of the *County* in which such school is situate.

It is hereby agreed that either of said parties to this contract may, at any time, terminate said contract and the employment aforesaid, by giving to the other party *four weeks* notice in writing of its election to so terminate the same. [Here insert length of time.]

The said *Sarah K Davis* hereby accepts the employment aforesaid and undertakes that she will faithfully do and perform *her* duty under the employment aforesaid, and will observe and enforce the rules prescribed for the government of the school by the Board of Education and the Superintendent, or Principal, or Supervising Principal.

Dated this *May 29* day of *May*, 19 *12*

Board of Education of the
School District of

Edward Rogers
President,

C J Garwood
Sec

Sara K Davis
Teacher.

Medford Township
County of *Burlington*

NOTE—A written contract is not required in the case of a teacher whose tenure is fixed by the Tenure of Office Act.

Above is the teacher's contract for Sara K. Davis dated May 29, 1912. The framed contract hangs on the wall of the restored Cross Keys School on Mill Street. Her yearly salary was $405 and was divided into nine monthly payments. She was the only teacher at the school, and her day usually extended from 8:00 a.m. to 4:00 p.m. with an hour recess for lunch at noon. Her students, many from the same families, ranged in age from six to 18 and were the children of farmers. (Courtesy of the Medford Historical Society.)

This formal photograph of Cross Keys School teacher Sara Davis is dated 1911. Her career in Medford started in 1907, when she began teaching at several of the township's rural schools. When the Milton H. Allen School opened in September 1927, she was a fourth-grade teacher there. Each Christmas, she arranged for Santa Claus to visit her classroom. She also provided gifts of candy and oranges to her students. Davis never married, a common practice for female teachers at the time. (Courtesy of the Medford Historical Society.)

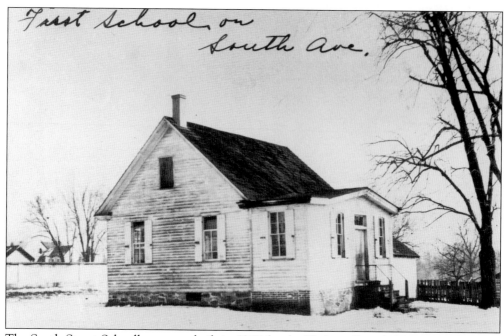

The South Street Schoolhouse was built in 1840 for the Hicksite Friends Meeting. It handled overflow students from the Filbert Street School in 1901. Students included Phil Mingin, Alfred McFarland, Fred Watson, Bertha Friend, Leon Sanders, Harry Simmerman, Raymond Cowperthwait, Edith Homan, George Hiles, Earl Piper, Boyd Piper, John Piper, Norman Piper, Kingdon Vaughan, Fred Gower, Beatrice Worrell, Lulu White, Percy Sharp, Clarence Henry, Mabel Stockurn, Norman McFarland, Helen Gibbs, Ethel Haines, Lottie Friant, Reba Gibbs, Joseph Phifer, Emily Gaskill, Ruth Mickle, Howard Cheeseman, Rachel Phifer, Roy Mickle, Jane Stockurn, Laurence Kane, Russell Worrell, Edna Worrell, Maurice Cline, and Ralph Johnson. Students below include Bill Lydon, Julia Haines, Ola White, Edith Clark, Willie Cotton, Clarence Adams, Lizzie Carter, Manus Fauver, Laura Sweeten, and Helen Warwick. The teacher is Julia Haines. This former school is now a private residence. (Both, courtesy of Beverly Mickle.)

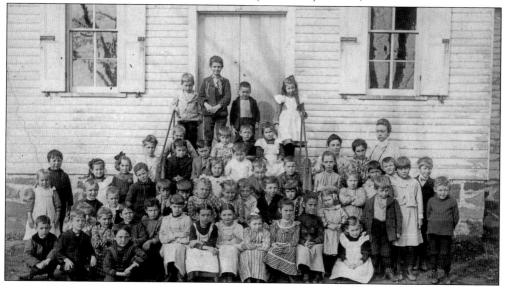

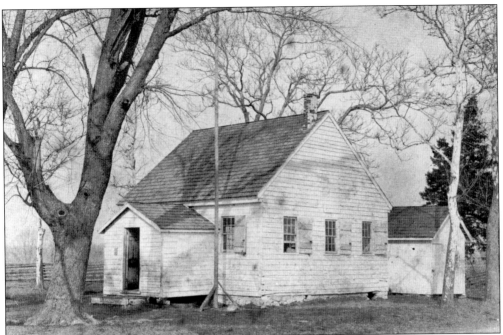

The Kirby's Mills School was located on the southwest corner of Church and Eayrestown Roads. In the group portrait are, from left to right, (first row) Bess Cowperthwait, Florence Stewart, Eva Stewart, Emma Hopkins, Anna Hopkins, Anna Wilkins, Mary Wilkins, Harley Wilkins, Lizzie Murdock, Manse Bennett, and Marty Bennett; (second row) Nettie Read, Flora Wilkins, Sally Hopkins, Vivian Norcross, Carrie Smith, Sallie Norcross, teacher Mattie Reynolds, Samuel Lewaller, Horace Britton, and George Wright; (third row) Louis Wright, Abe Hutchinson, Will Cowperthwait, Dan Bennett, George Peters, Al Hutchinson, Harry Shivers, George Hopkins, and Frank Bennett. Student Bess Cowperthwait went on to be a teacher in the school district and a principal at the Filbert Street and Allen Schools. The Kirby Mills School closed in 1919. (Both, courtesy of Beverly Mickle.)

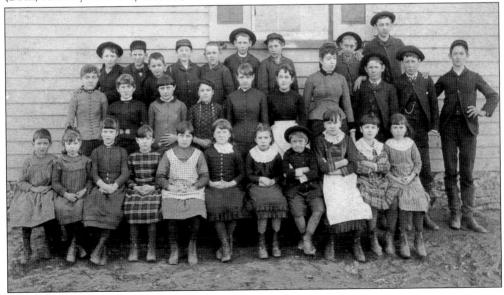

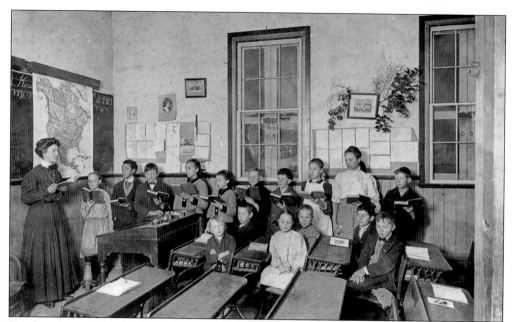

Teacher Anna Allen leads students inside the Brace Road School in 1908. The oldest of the rural schools, it was located on Church Road near Ark Road. In Dr. James Still's autobiography, he mentions that he attended this school in the early 1830s. He only went to the school for "one month each winter" when he was under contract to Amos Wilkins. The school closed in 1918. (Courtesy of Beverly Mickle.)

Students play outside the Union Street Friends Schoolhouse during a celebration marking 100 years of the Meetinghouse building. When the Quakers came to Medford, they built a school before building their meetinghouse. The school was considered new in 1759 and was closed in 1898 after nearly 140 years. It is the third school building in the town surviving into the 21st century. (Courtesy of the Medford Society of Friends.)

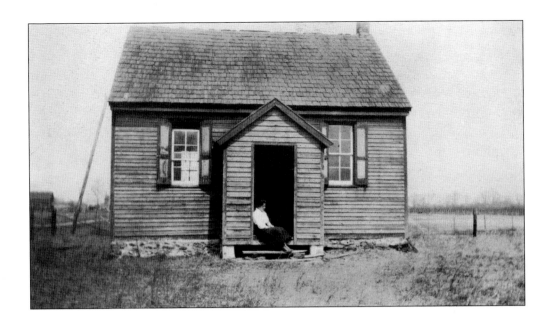

In an early photograph of the Chairville School (above), a woman sits in the doorway of the one-room schoolhouse. The school was situated on Chairville Road, just north of the present Route 70 on the eastern boundary of the township. The school served the once-flourishing town of Chairville, where there was a sawmill, a chair factory, two general stores, a Methodist chapel, and many farms. In the group photograph below, students are shown dressed in the finest clothes for the photograph. It was the first of the rural schools to close down. (Both, courtesy of Beverly Mickle.)

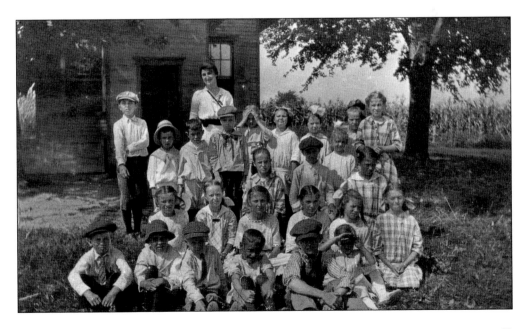

In the postcard above of the Filbert Street School, it is labeled as the Medford High School. Opened in September 1876, it served Medford students for more than 50 years. In the beginning, the school housed six grades with two classrooms on the first floor and one on the second floor. The photograph below shows the fifth- and sixth-grade classroom of teacher Mary Duppler. A partial high school was conducted in 1889, when the large upstairs classroom was divided to make space for a two-year high school program. When an addition was built onto the school in 1907, the high school was expanded to three years. In 1916, all high school students were sent to Mount Holly. A high school didn't return to Medford for more than 40 years. (Above, courtesy of Diane Stiles Cosaboon; below, courtesy of Beverly Mickle.)

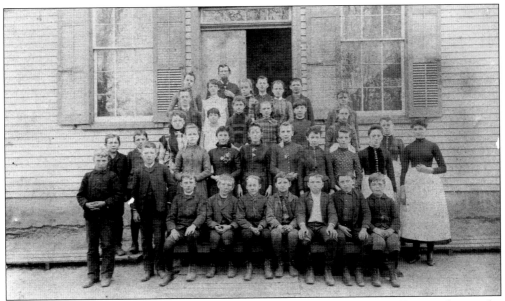

This group portrait, taken around 1892, shows Principal Milton Hannah Allen standing in the back of the group of students gathered on the steps of the Filbert Street School. It was said that he drew the plans for the school. By the time of this photograph, he had been teaching in Medford schools for almost 40 years and was the first principal in the Medford school system. (Courtesy of the Medford Historical Society.)

From left to right, eighth-grade female graduates Mae Ballinger, Ruth Evans, Bessie Wilkins, Louisa Wright, Stella Juliana, Alice Clark, Gladys Joyce, Clara Hewitt, Blanche Wilkins, and Florence Brown stand behind the Filbert Street School in 1926. Their teacher (center) was Elizabeth "Bess" Cowperthwait. There was a saying about their tall teacher, "Old Bess Cowperthwait, six feet tall, head in the parlor, and feet in the hall." (Courtesy of Mae Novelle.)

Milton Allen was both teacher and principal in the Medford school system. When he started teaching in 1854 at 16 years old, he was paid 3¢ a day per pupil. He then attended the State Normal School in Trenton for training. Afterwards, he returned and opened a private school on Branch Street that is now a private residence. When the Filbert Street School opened in 1874, he was named principal, chief teacher, and janitor. He was a strong believer in physical fitness for students and often pitched and umpired baseball games at recess. He retired from teaching in 1899 to become a justice of the peace. The school on Allen Street, in the architectural drawing below, was named in his honor. (Left, courtesy of the Milton Allen School Archives; below, courtesy of Beverly Mickle.)

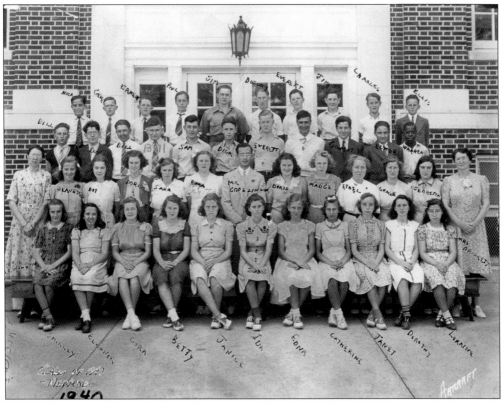

The graduating eighth-grade class of 1940 poses for a group photograph in front of the Milton H. Allen School. At the center is Principal Eric Groetzinger, who succeeded Elizabeth "Bess" Cowperthwait as the second principal. The first names of the students are written on the photograph. (Courtesy of the Milton H. Allen School Archives.)

Elizabeth "Bess" Cowperthwait (right) is pictured with her mother and sister. Bess was a longtime teacher in the Medford school system. She became the principal at the Filbert Street School in 1918 and became the first principal at the newly opened Milton H. Allen School until she retired in 1939. She organized the move from the Filbert Street School as each student carried their books in sacks three blocks away to the new Milton Allen School. (Courtesy of Beverly Mickle.)

PROGRAM

Medford Public School
Sixth Annual Picnic
ON THE SCHOOL GROUNDS
Thursday, June 10, 1920, at 1 P. M.

IF STORMY WILL BE HELD FRIDAY, JUNE 11, 1920

1. PARADE Led by Medford Fife and Drum Corps.
2. FLAG SALUTE and SINGING.
3. FLAG DRILL Grade 5.
4. FORMAL GYMNASTICS Entire School.
 Leaders, Miss Pew and Miss Wills.
5. RHYTHMIC PLAYS:
 Shoemakers Dance ⎫
 Chimes of Dunkirk ⎬ Grade 1
 Lads and Lassies. ⎭
 Carrousel Grade 2.
 Children's Polka ⎫
 The Roman Soldiers ⎬ Grade 3.
 Sailor Boy ⎭
 Oats, Peas, Beans and Barley Grow
 Captain Jinks Grade 4.
6. FOLK DANCES:
 The First of May Grade 2.
 Indian War Dance Grade 5.
 Come Let Us Be Joyful Grade 5.
 May Pole Dance Grade 6.
 French Vineyard Frolic ⎫
 Ribbon Dance ⎬ Grades 7 & 8.
 Minuet
 Gustafs Skol ⎭
7. DRILLS:
 Clap, Hurrah! Grade 1.
 Flower Drill. "Hearts and Flowers" Grade 2.
 Rhythm Medley Grade 3.
 Base Ball Drill Grammar Grade Boys.
8. SINGING GAMES:
 Go Round and Round the Village Grades 1 & 2.
 Itiskit, Itaskit Grade 2.
9. GROUP GAMES:
 Cat and Mouse Grade 1.
 Run For Your Supper Grade 2.
 Overhead Relay Grade 4.
 Chinese Wall Grade 4.
 Dress Relay ⎫
 Corner Spry ⎬ Grade 5.
 Numbers Change ⎭
 In and Out Relay ⎫
 Post Relay ⎬ Grade 6.
 Black and White ⎭
 Alley Tag ⎫
 Jump the Shot ⎬ Grades 7 & 8.
 Round Ball ⎭
10. ATHLETIC CONTESTS:
 #### BOYS:
 1. 100 yard Dash
 2. Running Broad Jump
 3. Base Ball Throw
 4. Relay Race (4 runners 110 yards each.)
 #### GIRLS:
 1. 50 yard Dash
 2. Standing Broad Jump
 3. Base Ball Throw.
 4. Relay Race (6 runners 50 yards each)
 (Ribbons will be awarded the winners)

LEADERS AND ASSISTANTS

Stanton Braddock	Sarah Wilkins
Donald Wescott	Edna Pew
Cheston Cowperthwait	Mildred Bowker
Stanley Haines	Esther Engle
Leslie Wright	Emily Twing

The program for the sixth annual picnic on the Filbert Street School grounds was handed out to those who attended the event on Thursday, June 10, 1920. The program included a parade, plays, dances, singing, group games, and athletic events for boys and girls. (Courtesy of the Milton H. Allen School Archives.)

Shown are individual portraits of seventh graders at the Filbert Street School taken in October 1927. Their teacher was Mrs. Roth. The students are, from left to right, (first row) Joseph Kumple, Rose Wells, Gladys Cheeseman, Ester Gager, Ada Stoops, M. Bacon, and Harold Bacon; (second row) Peter Juliano, Fred Ueckert, Maurice Kumple, Doris Wright, Irene Ballinger, Dorothy Westwood, Norma Prickett, Harold Wolfrom, and Emma Homan; (third row) Francis Brown, Alice Simons, Charlotte Homan, Sara Barnes, Dorothy Mortimer, Charles Adams, Wanda Kotula, Freeman Ueckert, and Roland Casaboon; (fourth row) William Cheeseman, Harold Adams, Edwin Forsythe, Florence Cook, Dorothy Champion, and Alice Shover. Edwin Forsythe went on to become a US Congressman and served the area from 1971 to 1984. (Courtesy of Ed Gager.)

Cross Keys School December, 1911

Students — Class Size — 23 pupils
Shontz Hiles
 Albert Nola
 Russell Stanley
 Hilda Mildred
 Charles Dixon
Anderson Lillie
 Sarah Borton
 Lydia Mary
 Joseph
Schrider
 Neila Certified All Present
 Mabel Miss Seiber
 Lizzie Teacher — Last year of
 Dewey Contract
Machlette Dewey skinned Nose
 Howard 12 horses
 Gertrude Lose shoe on shake
Crispin Sore, right flank,
 Lawrence Hoof.
 Francis Low on Oats
 Arthur Delivered
Edelson Two Cords Green Oak
 Ida house across street.
 Bella Well: frozen — opened

A note from December 1911 by Helen Seiber shows the names of those in attendance at the Cross Keys School. Twenty-three pupils attended the one-room schoolhouse in the southern area of the township, but they were only from nine families. The note describes how Dewey Schrider skinned his nose. Also on the note, there were 12 horses outside the school, and she described some of their conditions. She noted that two cords of green oak wood were delivered for the school's stove. The final notation was that the well, located across the street, was frozen and then opened. (Courtesy of the Medford Historical Society.)

Six

DR. JAMES STILL

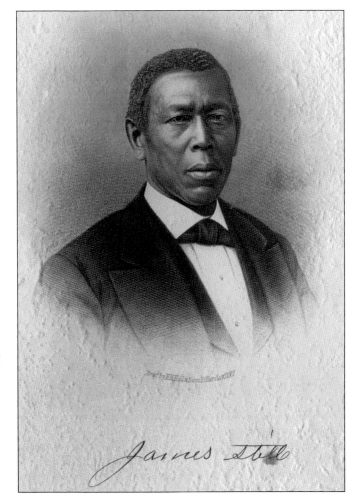

Dr. James Still, the son of runaway slaves, was born in 1812 in Shamong Township. He moved to Medford under contract to Amos Wilkins at 18 years old. Known as the "Black Doctor of the Pines," he built a home and then an office on Church Road in the Cross Roads section of the township, serving the sick with his herbal lotions and tonics. (Courtesy of the Medford Historical Society.)

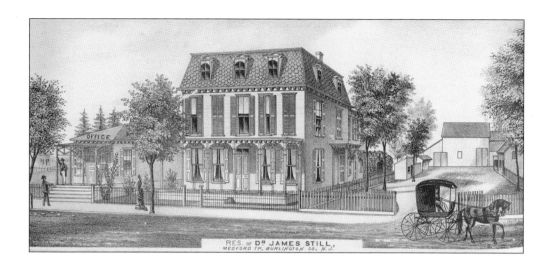

RES. of DR JAMES STILL,
MEDFORD TP, BURLINGTON CO., N.J.

The drawing of the residence and office of Dr. James Still in 1876 shows a house with a 40-foot width and 26-foot depth, a mansard roof, running water, and all the modern improvements. In 1855, he built the office with basement rooms where he made his syrups. In 1932, the house was demolished, with only the office remaining. The office was entered on the New Jersey Register and the National Register of Historic Places in 1995. The New Jersey Department of Environmental Protection Green Acres Program preserved James Still's property in 2006. Later that year, relatives of Dr. Still celebrated with his office in the background. The eight-acre Medford parcel is the state's first African American historic site. (Above, courtesy of the author; below, courtesy of the *Burlington County Times*, photograph by the author.)

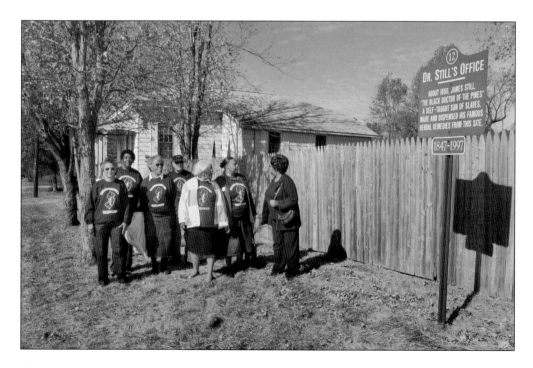

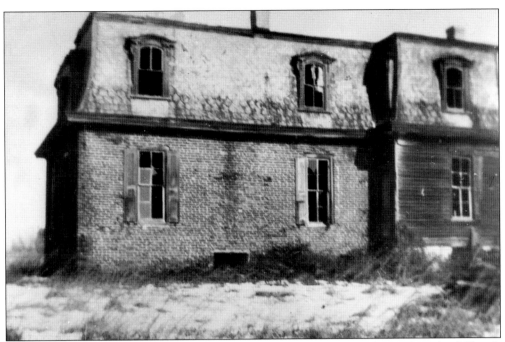

The Upper Evesham Township Town Hall (above) at Cross Roads was located north of Church Road on Mount Holly Road. When Medford separated from Evesham, it served as Medford's town hall, and the first township meeting was held there on February 4, 1847. In his book, Dr. Still talks about buying the town hall property in 1868 and improving it four years later with a mansard roof and converting it into "two snug dwelling-houses of seven rooms each." Dr. Still also purchased the tavern at Cross Roads (below). In 1859, he began rebuilding it, making it 40 feet wide, 30 feet deep, and three stories high. It is said he used some of the rooms in the converted tavern as a hospital. (Above, courtesy of Leona Snyder; below, courtesy of the Collection of the Burlington County Historical Society, Burlington, New Jersey.)

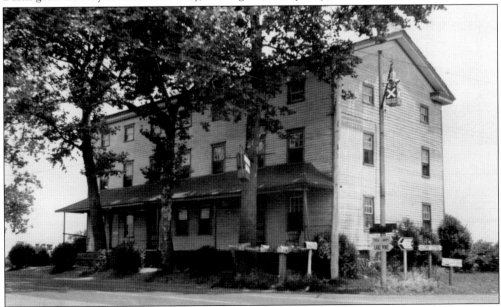

Dr. James Still's Remedies.

Dr. James Still's
ALTERATIVE,

For Cancers, Tumors, Eczema, Etc., and all Blood Diseases. The best Spring and Fall blood medicine known. Only one size; full half pint bottle, **50 cts.**

Dr. James Still's
BLACK SALVE

For Ulcers, Cuts, Warts, Corns, Burns, Felons, Boils, etc., and for all healing and cleansing purposes. Only one size, **25c.**

Dr. James Still's
Anti-Bilious Pills

For Constipation, Biliousness or Sour Stomach, etc. It is well known that they cure the Headache. Only one size; **10c.**

Shown at left is a page from Dr. James Still's trademarked famous remedies and vest pocket notebook produced by the Still Manufacturing Company of Medford. The company offered the same bottled and boxed remedies at the same price as Dr. Still, but they are now presented by L. Still, president, and Thomas Still, business manager. Below is a license issued by the State of New Jersey to James Still to carry on the business or occupation of physician on Main Street in the town of Cross Roads. The license is for the year September 1, 1862–September 1, 1863, and appears to be a tax license to run his business as a physician. (Left, courtesy of the Medford Historical Society; below, courtesy of the Collection of the Burlington County Historical Society; Burlington, New Jersey.)

Seven

PUBLIC SAFETY

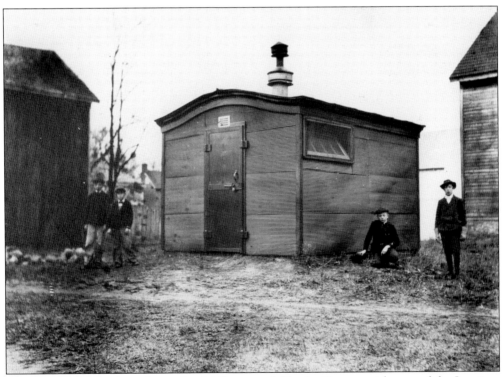

The first Medford jail was located at Mulberry and Charles Streets, with part of the Jennings Cranberry House at right. Standing outside the unusual building are Floyd Branin, Sam Haines, Frank Wolf, and an unidentified boy in 1904. The next jail was located upstairs in the Main Street firehouse, where the courtroom was also located. (Courtesy of Beverly Mickle.)

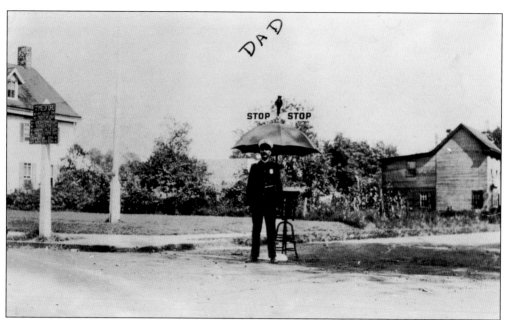

Medford police chief Nelson Peake stands at the intersection of Main and Bank Streets with a traffic control device, umbrella, and chair directing traffic in 1920. Longtime Medford resident Mae Novelle recalls, "in the Twenties we had just one policeman. There was no traffic light, so he stood in the street and turned the stop sign." Behind Chief Peake is the Lamb House at left and a sign with distances to various towns. Some of the distances are Trenton, 28 miles; Hammonton, 22 miles; and Atlantic City, 52 miles. Below is the oath card that Nelson Peake swore to become a police officer in 1922. (Above, courtesy of Beverly Mickle; below, courtesy of the Medford Township Police Department.)

Oath of *Special Police*

I, *Nelson W. Peake* do solemnly and sincerely promise and swear that I will in all things, to the best of my knowledge and understanding, well and faithfully execute the trust reposed in me as *Special Police* of the Township of Medford, in the County of Burlington, serving until *December 31, 1922*

Subscribed and sworn to before me this *2nd* day *Jany.*, A. D., 19*22*

Nelson W. Peake

H. Bowker
Clerk.

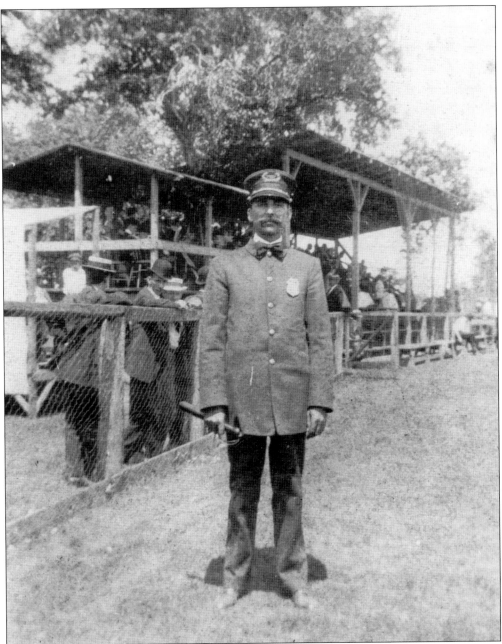

Medford police chief Nelson Peake stands in front of the crowds at the Medford Field Club on North Main Street in 1910. Chief Peake was the only full-time police officer at the time, but the police records show that there were many special police officers sworn in for part-time duty over the years. One of the special police officers was Jay Friant, the town barber. Just as police officers today are sent for crowd control at large events, Chief Peake was at any gathering of large people, especially if the out-of-town crowds were rowdy during a baseball game. (Courtesy of Beverly Mickle.)

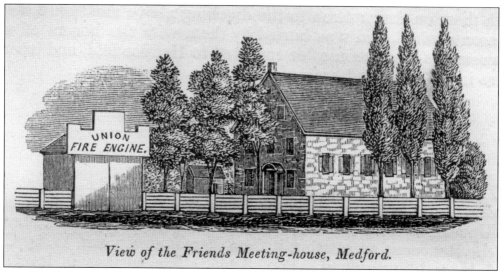

View of the Friends Meeting-house, Medford.

The first Union Fire Company building (above) was constructed in 1821 on the grounds of the Union Street Friends Meeting House. Before, members of the company kept leather buckets filled with water at handy places inside the meetinghouse, marking the beginning of the Union Fire Company. A reconstructed building stands at the site today. (Courtesy of the author; engraving from the *Historical Collections of New Jersey* by John Barber and Henry Howe.)

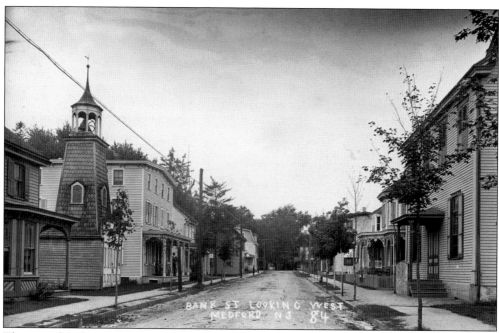

The second firehouse (left) at 28 Bank Street across from the Temperance Hall was built in 1872. Some of the costs involved were $103.99 for lumber from Charles Proud and $25 for carpentry work by E.B. Brown. The old ladder wagon, which carried six ladders of various sizes, and some leather water buckets were housed inside. A large bell was housed at the top of the building to call the volunteers. (Courtesy of Beverly Mickle.)

The third home of the Union Fire Company was located on the same lot as the second building but was a concrete structure built in 1913. Coming out of the building is the company's first motorized fire truck. This building still stands on Bank Street today and is used as a garage. (Courtesy of Beverly Mickle.)

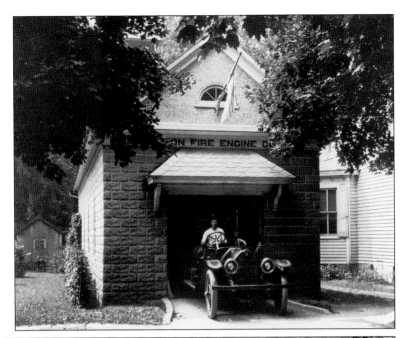

The next home of the Union Fire Company's Main Street Firehouse shows company members with a LaFrance truck in 1926. The photograph includes a who's who of Medford notables, including Charles Braddock, Charles Worrell, Everett Haines, Maurice Haines, Walt McClain, Pemberton Griscom, and Maurice Garwood. This building was closed when the new building was constructed on Firehouse Lane. (Courtesy of Beverly Mickle.)

During World War II, an airplane watchtower was built at 86 Union Street on the DeStefano farm property, now the site of Freedom Park. June Brown is seen in a uniform in the tower with directional arrows to her right. Although she didn't wear the uniform when she worked in the tower, she wore it when her mother took the photograph. June Brown, a member of the Aircraft Warning Service, worked in the tower as an observer in 1943 and 1944 when she was 13 years old. Her job was to look for Nazi planes coming in from the Atlantic. The housing at the top of the building is designed to look like a log cabin, similar to Medford Lakes homes built by Mancill Gager. As a result, credit for the building of the tower is sometimes given to him. (Above, courtesy of Beverly Mickle, photograph by Elizabeth Oliphant Brown; below, courtesy of June Brown Haines.)

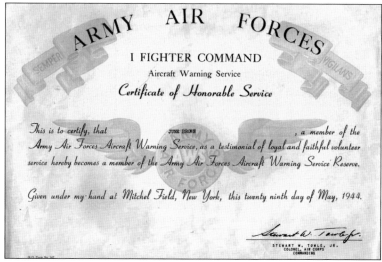

Eight

SOCIAL LIFE

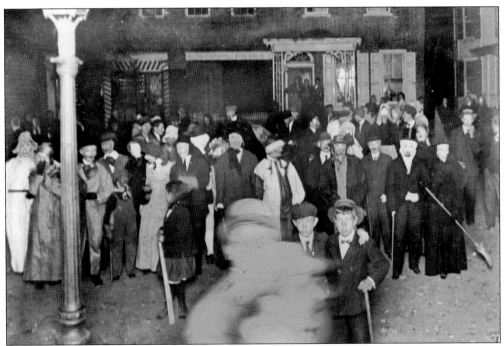

Medford's Halloween parade is one of the longest-running traditions in the township. Although the 2011 parade was listed as the 65th annual Medford-Vincentown Rotary Halloween Parade, photographs show that a Halloween parade has been taking place in the township off and on since the early 1900s. This photograph shows a gathering on Main Street in the early 1900s with Bertha Friend Mickle on the right dressed as a witch. (Courtesy of the Medford Historical Society.)

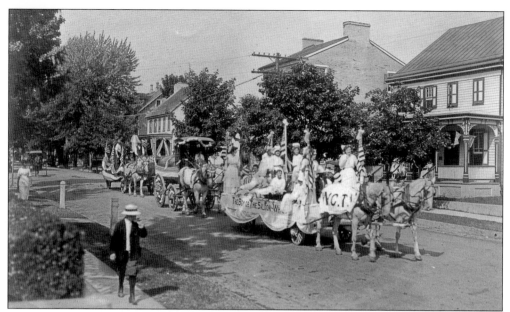

The Old Home Week Parade on South Main Street featured a float with members of the Women's Christian Temperance Union (WCTU) in August 1914. On the side of the float is written "The Boy or The Saloon—Which One." In the pre-Prohibition years, the WCTU was a large influence in promoting the end of the consumption of alcohol across America. (Courtesy of Beverly Mickle.)

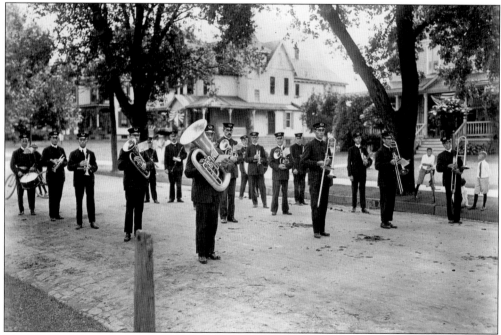

The Medford Citizens Military Band practices on North Main Street prior to a parade in 1908. Included in the photograph are Ed Stone, Bill Ray, Tobbie Carrigan, Bill Foster, George Mingin, George Foster, Edward Wills, Jake Bowker, King Vaughn, and Conrad Miesle. The band often traveled by train to other towns to perform in their parades. (Courtesy of Beverly Mickle.)

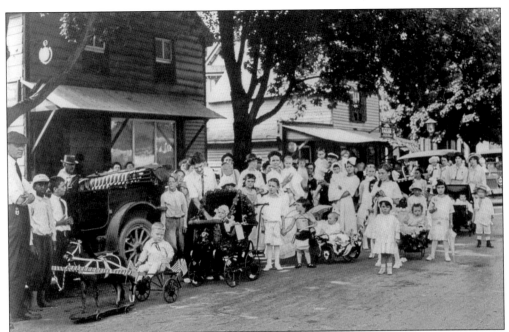

Children and parents line up on North Main Street for a baby parade in 1916. The building behind at left is Mel Oliphant's Notion Store. At left is Everett Haines, the leader of the parade. Second from left is Bernard Blake, and the boy standing to the right of the car is Maron Vaughn. Baby parades are still a popular feature in the area, especially in New Jersey Shore communities. (Courtesy of Beverly Mickle.)

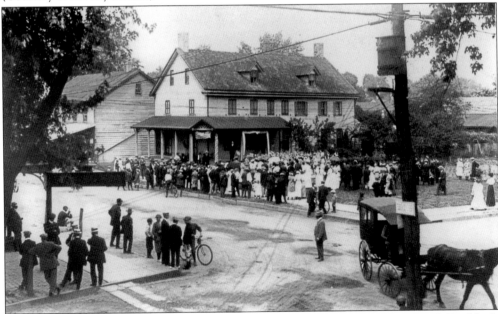

The empty lot in front of the Lamb House was the site of a war rally in 1917. Frank Braddock, chairman of the township council, is shown standing in the middle of Main Street. The land at the northeast corner of Bank and Main Streets was the scene of rallies, circus performances, and other travelling shows and served as the unofficial town square. (Courtesy of Beverly Mickle.)

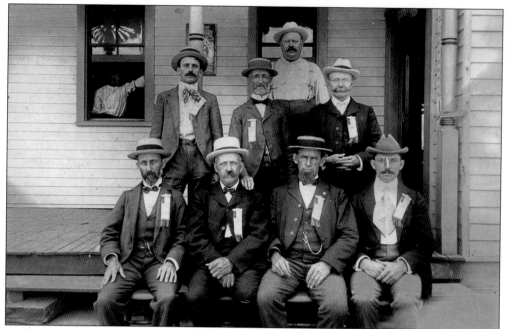

Medford Grange members with delegate ribbons on their jackets sit near the front steps of the hotel where they were staying in Atlantic City at the annual National Grange Convention in 1905. The only identified member of the group is Edmund Braddock, who is second from right in the front. (Courtesy of Roberta Shontz.)

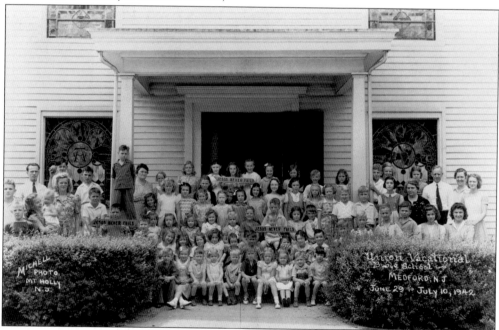

The Methodist and Baptist church combined vacation Bible school students stand in front of the Methodist church on Branch Street in July 1942. Rev. Kenneth Stevens, the Methodist minister, stands at right, and Rev. Walter Rodgers, pastor of the Baptist church, stands at left. (Courtesy of June Brown Haines.)

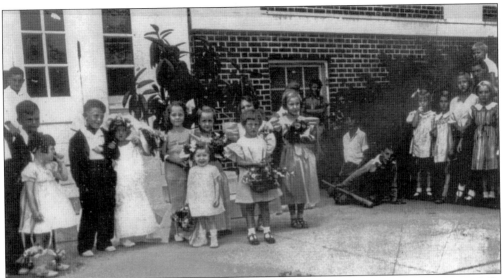

A Tom Thumb wedding takes place at the Milton Allen School in 1934. The groom is Billy Thompson, and the bride is Arden Worrell. Tom Thumb weddings, featuring children in the major roles, were a national fad in the early 20th century based on the real-life wedding of little people Gen. Tom Thumb (Charles Stratton) and Lavinia Warren in 1863. (Courtesy of June Brown Haines.)

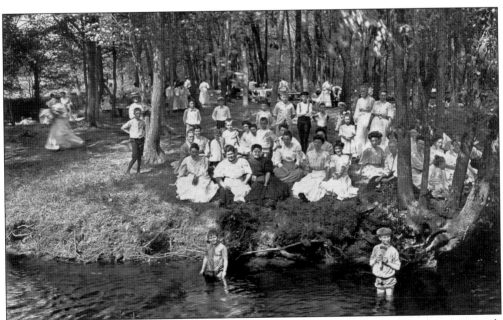

The Methodist Sunday school picnic was held at Taunton Lake in 1910. The picnic grounds were located across the road from the Taunton Mansion, formerly owned by Joseph Hinchman. It was one of the most popular recreation spots for church groups and social groups up until World War I—for those willing to travel on the rutted, sandy roads to get there. (Courtesy of Beverly Mickle.)

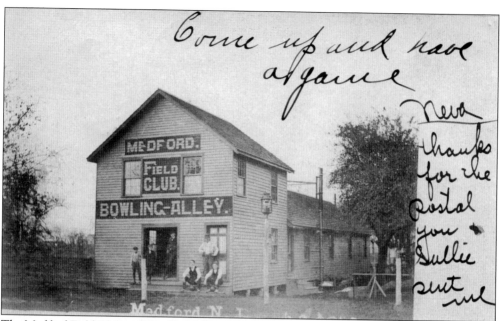

The Medford Field Club and Bowling Alley was part of the North Main Street athletic complex in the early 1900s. The building was located along the first-base side of the baseball field. It was moved to Union Street around 1915 and became a home. (Courtesy of the Medford Historical Society.)

Members of the West End Camping Club gather below the South Main Street Bridge on the west side of Mill Street. They were probably playing cards and drinking at Minnie Hole, located behind Bunning Field. The spot was a popular place for workers from the glass works to gather. There was a swimming hole and park-like area along the Rancocas Creek. (Courtesy of Beverly Mickle.)

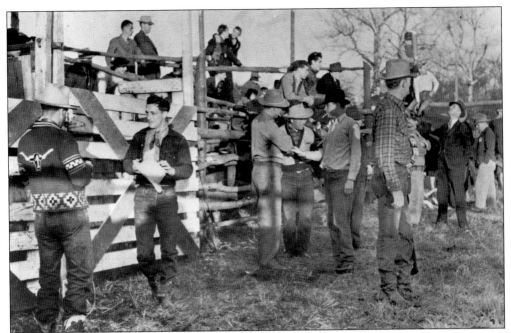

Riders gather at a rodeo held in the Christopher's Mill area in the 1930s or 1940s. Former Medford resident Ed Gager remembers attending a rodeo on the farm owned by Tom Burr in the 1950s when he went with his older brother. The rodeo included steers and horses and was a weekly event during the summer months. Riders came from Blackwood and Clementon to compete there. (Courtesy of Beverly Mickle.)

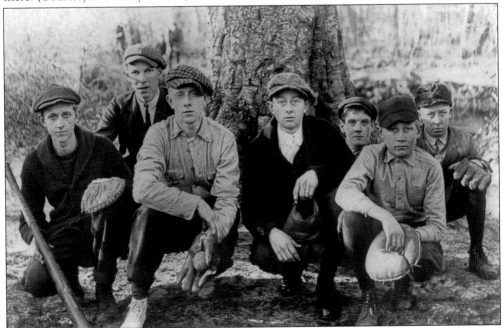

Boys gather with their equipment near the Mill Street Ball Field, now Bunning Field, in 1910. Engle Kirby remembers playing pickup games in the 1930s with his friends at various locations in Medford, including backyards. (Courtesy of Beverly Mickle.)

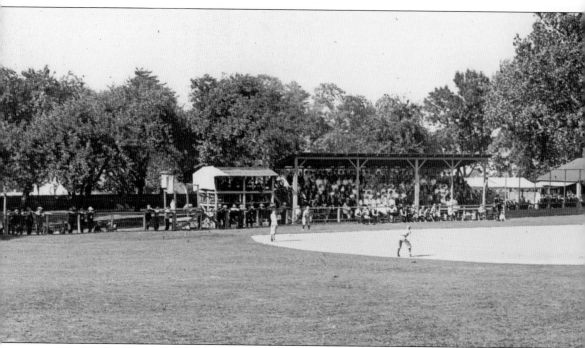

The Medford Field Club field was the main baseball field in the late 1800s and early 1900s. This photograph from 1912 shows the area that now includes 76 to 86 North Main Street. The house at far right is 79 North Main Street, formerly belonging to Ralph Durr, longtime president of Burlington County National Bank. The residence and barn to the right of the flagpole is 89 North

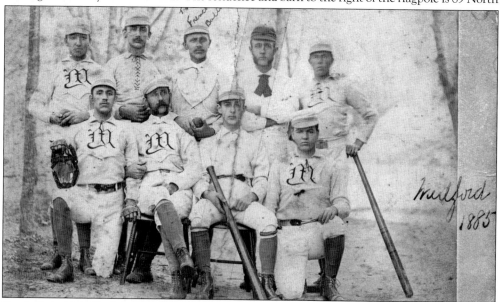

Baseball and Medford seem to be synonymous at the beginning of the 20th century. No other sport attracted crowds and had fields as spectacular as baseball. This 1885 team included Thomas French Ballinger (third from the left in the second row). Newspaper accounts in the early 1900s listed game results with dramatic headlines on page one of local newspapers. (Courtesy of the Medford Historical Society.)

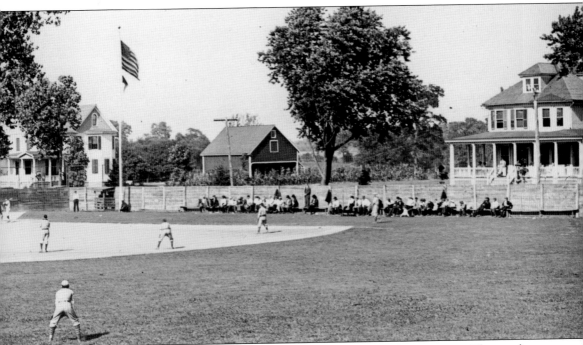

Main Street, formerly Albert Kirby's house. The fence at right contains advertisements. The stands and concession stand are located on the first-base side of the field. The large buttonwood tree in the center is still standing. The field was no longer used after 1920. (Courtesy of Beverly Mickle.)

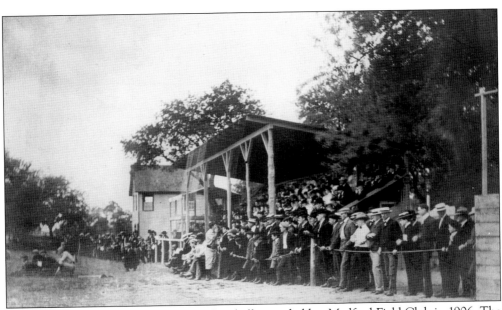

Spectators crowd the field in 1906 at a baseball game held at Medford Field Club in 1906. The teams and fans usually travelled by train to the fields in Vincentown, Mount Holly, and along the Delaware River, including Riverside, Roebling, Burlington, and Bordentown. Games usually ended when it was train time, no matter the score or inning. If one missed the train, there wasn't another until the next day. (Courtesy of Beverly Mickle.)

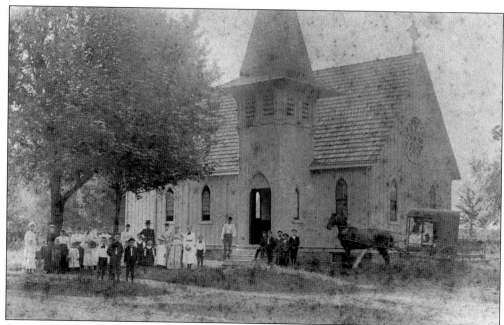

Sunday churchgoers gather outside St. Peter's Episcopal Church on Union Street in 1880. In 1959, Dr. Albin Ernst Scheibner and wife Merilyn bought the church building, which was constructed in 1875. He used it as his chiropractic offices until 1992. Currently, it is the home of their daughter Erna Scheibner. (Courtesy of Beverly Mickle.)

During the 100th-anniversary celebration of the building of the Union Street Friends Meeting House, cars were parked on the meetinghouse lawn on August 1, 1914. Nearly 500 people gathered to listen to literary entertainment, eat lunch, and meet with old acquaintances. The first meeting of Quakers in Medford was believed to be held around 1762. (Courtesy of Beverly Mickle.)

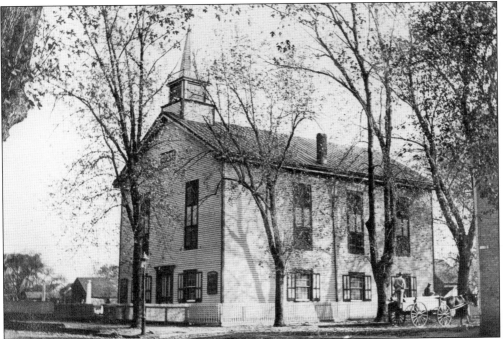

The Methodist Episcopal church, built in 1854, was located on the corner of Branch and Filbert Streets. Eight stained glass windows in the church were removed in 2003 and sold to private buyers on the west coast. The United Methodist church moved to the corner of Hartford and Taunton Roads in 1972. The building is currently the home of the Liberty Tabernacle Family Worship Center. (Courtesy of Beverly Mickle.)

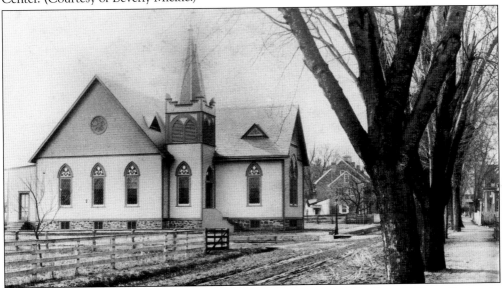

The First Baptist Church of Medford was built on the corner of Bank and Filbert Streets in 1892. The first church building, at the corner of Bank and McClain Streets, opened its doors in 1842 with Rev. John Richards as the first minister. The first building opened before Medford was incorporated as a township, and the church has served the community for more than 170 years. (Courtesy of Beverly Mickle.)

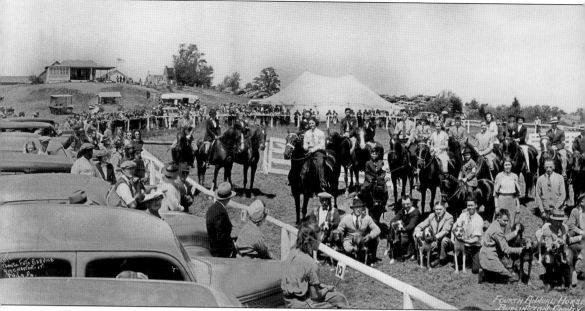

The Fourth Annual Horse and Hound Show was held at the English Setter Club of America grounds on May 7, 8, and 9, 1939. Annual trials and events have been held in Medford since 1912. The grounds were purchased by the organization in 1918. The club is located near the northern border with Lumberton. On its grounds is one of the oldest buildings in Burlington County, a

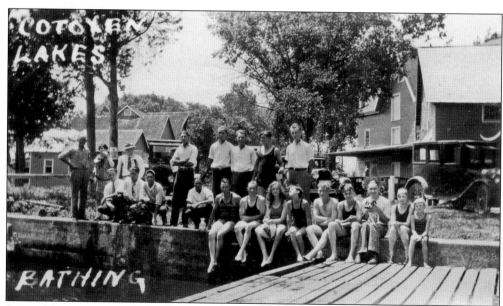

Swimmers at Lake Cotoxen sit along the concrete wall near the dam with the Kirby's Mill buildings in the background. The dam at the mill provided a lake for swimmers who traveled from nearby towns to swim in the cedar-infused water. The well-known swimming hole, located on the Rancocas Creek, is now more known for fishing and canoeing. (Courtesy of Charles and Grace Haines.)

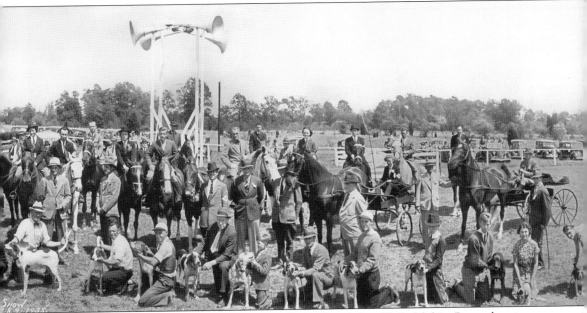

house built by Thomas Wilkins in 1732. The club was founded in Philadelphia, Pennsylvania, in 1906 by Frank Reily, who was part-owner of the Star Glass Company, and George Thomas of Chestnut Hill, Pennsylvania. The club is still active and regularly holds events on its large campus. (Courtesy of Ed Gager.)

A group of hunters gathers in front of a log cabin in the area of Medford Lakes after a successful day. The man eighth from the right is Leon Todd. He was instrumental in the founding of the Medford Lakes community. Hunting was a part of the community, although there were no buildings dedicated to hunting clubs in the early 1900s. Many informal groups, such as the Foxy Gunning Club, gathered to camp, hunt, and spend time together. (Courtesy of Ed Gager.)

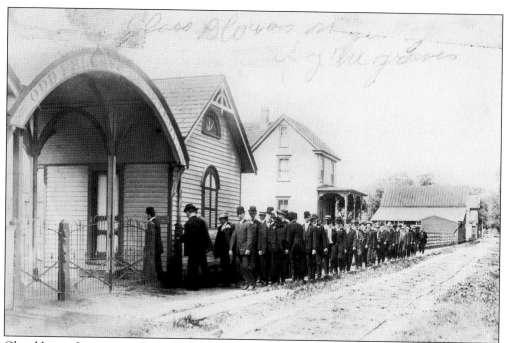

Glass blowers line up outside the Independent Order of Odd Fellows Cemetery on Coates Street to tend the graves. The workers at the Star Glass Company did not work during the heat of the summer. They sought work during those months picking fruit or vegetables or used their time to do public service. The dam at Kirby's Mill broke in the early 1900s, and the workers rebuilt the dam in the summer of 1912. (Courtesy of Beverly Mickle.)

William Loeffler stands with a group of horses outside the Tip-Top Riding Academy in 1942. The riding school was located on Stokes Road, just on the border with Medford Lakes. The sign behind him says "Evening & Moonlight Rides." They probably rode along the paths by the lakes and bogs of what is now Medford Lakes. They also brought horses out to the YMCA camps for riding lessons. (Courtesy of Ed Gager.)

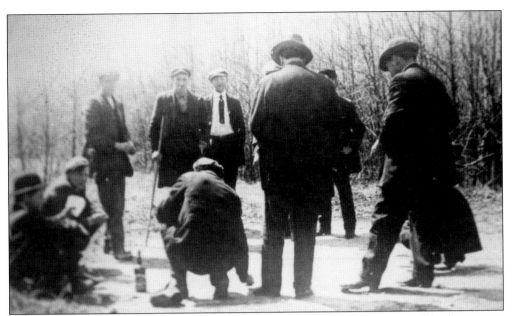

A craps game is captured in progress at Minnie Hole in Medford. Minnie Hole, whose name origin is unknown, was a gathering place for people behind Bunning Field. There was a swimming hole from the blocked Rancocas Creek, but there were also benches, tables, and open areas for playing. Old timers in Medford recall the area, located close to the glass workers' houses, with fondness. (Courtesy of Beverly Mickle.)

Women from the Epworth League of the Medford Methodist Episcopal Church stop on Branch Street near Broad Street in the early 1900s prior to marching in a parade on Main Street. Second from left is Ethel Mortimer, and fourth from left is Emma Jean Stackhouse. The Methodist young adult organization was founded in 1889 in Cleveland, Ohio, and is still active today. (Courtesy of Beverly Mickle.)

Boys gather at the Sunday ice cream social held at the Hicksite Friends Meetinghouse yard on South Street around 1902. The ice cream came from Pott's Ice Cream Parlor at 26 South Main Street. Pictured are, from left to right, Herbert Griscom, Charles Reeve, Charles Griscom, William Dyer, Carlton Garwood (behind the ice cream tub), Coral Mingin, Walt McClain, Clarence Mingin, and William Griscom. (Courtesy of Beverly Mickle.)

In 1899, the wedding party of Albert and Anna Kirby stood on the porch of the family home, located just north of the present Route 70. Anna Branin and Anna Kirby are the flower girls on each side of the wedded couple. Alfred Darnell and Bertha Kirby stand at left. Ella Branin (right) holds the hand of the flower girl. This magnificent house still stands on Eayrestown Road across from the Route 70 Wawa. (Courtesy of Beverly Mickle.)

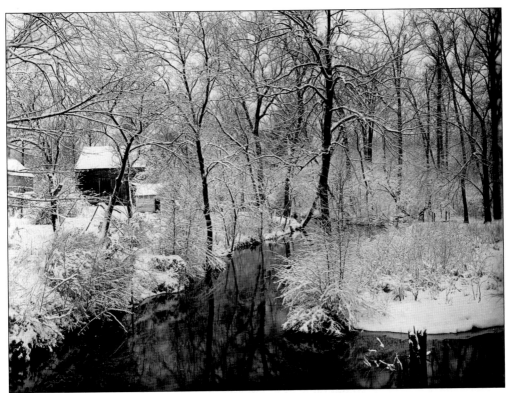

This timeless winter scene, taken from the South Main Street Bridge, shows the Rancocas Creek in 1912. William B. Cooper (right) took the photograph and lived with his family on Bank Street. In the 1910 census, he listed himself as a photographer, but when he died in 1942, there was nothing mentioned about his photography career. A multitalented man, he took out a front-page advertisement in the *Central Record* in 1912, running "Automobile Parties" to Atlantic City for $7. He also ran a hardware store on Main Street in his later years. Many of the photographs in this book were taken by Cooper. As a fellow photographer, I am deeply indebted to him. (Both, courtesy of Beverly Mickle.)

DISCOVER THOUSANDS OF LOCAL HISTORY BOOKS FEATURING MILLIONS OF VINTAGE IMAGES

Arcadia Publishing, the leading local history publisher in the United States, is committed to making history accessible and meaningful through publishing books that celebrate and preserve the heritage of America's people and places.

Find more books like this at
www.arcadiapublishing.com

Search for your hometown history, your old stomping grounds, and even your favorite sports team.